# *Wicked* ASHEVILLE

MARLA HARDEE MILLING

*Foreword by Joshua P. Warren*

THE
History
PRESS

Published by The History Press
Charleston, SC
www.historypress.com

Copyright © 2018 by Marla Hardee Milling
All rights reserved

First published 2018

Manufactured in the United States

ISBN 9781467138802

Library of Congress Control Number: 2018942443

# CONTENTS

# Contents

# FOREWORD

*M*any do NOT want you to read this book.

Asheville's majestic blue and purple mountains glow, with a halo of silvery clouds, in glossy ads and slick TV commercials all over the world. The cozy streets explode with tourists who pour in for a fun experience, rambling on foot. The idea is to focus on a "good time," and yet, Marla Hardee Milling has decided to write this book about the dark side—the seedy things, the things we usually brush under the rug—called *Wicked Asheville*.

Why?

How much can we pay you, Marla, to just forget about all this, cram it in a manila folder and let the city ride its wave of positive income with a naïve smile?

Why do you need to point out the embarrassing, awkward and often shameful things in the past of this grand, southern gem?

What in the heck are you thinking???

Okay.

I suppose these are rhetorical questions. Why do I say this?

Well, Marla is a native of these mountains, just like me. And I know she doesn't want to hurt us. So here's what I'm thinking about her decision to write this controversial book…

Some of the world's smartest people—cosmologists and astrophysicists—tell us that all time is occurring at once. What you consider the past, present and future are all happening simultaneously. However, the human brain

is so diminutive it can only process this little by little, second by second, minute by minute, hour by hour, day by day, week by week, month by month and year by year—plus from a limited perspective or point of view.

Thus, in other words, as you stand in Asheville today, you are knee-deep in what happened in Asheville twenty years ago, one hundred years ago or even two hundred years ago.

Why is this important?

Because you can only grasp the identity of a place if you know its history—for better or for worse.

And to this very day, when you stand in the middle of downtown Asheville, with the Battery Park Hotel gleaming before a full moon as if you are on some movie set or in the middle of a miniature shadowbox, you are immersed within the entire, multilayered history of that site.

Many roaring and wonderful times were had in that grand building, but it also was the site of numerous suicides—depressed people jumped from the top. Let us therefore be honest about our view of the place. The tragedies were rare, but they *did* occur.

Some prefer to turn a blind eye, like an ostrich hiding its head in the sand, to the unpleasant elements of history. And yet, these elements give us the contrast by which we see the peaks and valleys more sharply.

So, in this book, Marla has firmly embraced the darkest sides of our community so that we can both have a fuller, and more realistic, sense of our complex identity, and to form that precious contrast so the good parts of our region pop forth even more vividly.

And even the darkest clouds do have a surprisingly silver lining. For example, Asheville was founded in the 1790s. And yet, in all these years, our largest mass murder, the Will Harris incident, which occurred in 1906, culminated in six dead bodies, including that of the madman himself. Six is not a huge number, especially when compared to other towns of similar popularity. Let us keep it that way.

It is true that all the soil of the world is drenched in blood. These mountains have certainly absorbed their share. And being positioned at such a sweet spot between the North and South, and near the coast, every type of swindler and weirdo has drifted through here at one time or another. It is therefore inevitable that twisted things will occasionally occur, and troubled genes get passed down through the generations.

It is, at the very least, *interesting* to reflect on the kinds of stories Marla has collected here. And, really, the tone of these tales is not so different from the kinds of disturbing headlines blazing across the news today. We

have a natural fascination with those things that go wrong. It all goes back to survival of the fittest. We evolved to be aware of danger so we can avoid it ourselves. Fortunately, these stories are newsworthy because they are, in fact, so rare. They are the gross exception to the friendly people and beautiful scenes.

The morbid joy in reading a book like this one may be similar to watching a horror movie. I wouldn't want to watch a horror movie every day, but once in a while, it's fun to let your mind drift into ghoulish territory. One thing is for certain about these scenic lands. During the day, when the sun shines and the air is crisp and clean and streams rush through the lush leaves and mossy rocks, Asheville can feel like a version of heaven. But late in the evening, when the sun slips away and darkness quietly creeps across the ranges, everything changes. The mountains are spooky, the curved, winding roads hiding whatever you can imagine—bandits or spirits or wild beasts of campfire tales.

To this day, there are strange lights in the woods that no one can explain. There are shady characters holed up doing secret things. There is an entire underground of activity just beyond the streetlights, tucked in the alleyways and perched on the cliffs above.

So let this book be a fascinating freak show but also a warning. Since Marla grew up here, she has a sixth sense for a juicy local story and uses her fine skill as a writer to beautifully capture the mysterious and macabre around us. Never forget that dark and twisted things happen everywhere, even here, in the "jewel of the crown" of the Blue Ridge Mountains, a tourist's dream.

My grandfather recently passed away at age ninety-four. He used to say that when he was young man, growing up in the nearby mountains, he woke up every day for work before the sun rose. In the cold predawn, he would walk miles to a sawmill. It was still and quiet in the morning. Except, frequently, as he would pass below one spot, up on a mountainside above, he would see a raging bonfire and hear the chanting of "witches." Their silhouettes would break up the flames as they danced around the fire. His heart would always race, and he would speed up to pass the spot. It would make his blood run cold.

My grandfather was a very religious man. Who knows what was really happening up on that mountain on those mornings? He never ventured there to investigate further. But all throughout history, I've heard stories about an obscure level of our town that is usually unseen—just behind the ridge or around the bend. Some believe there is a reason that Asheville has the word *evil* right in the middle.

Joshua P. Warren.

We may never know all the strange and unsettling things that are hidden just out of sight in these dense, enchanted lands. But here, Marla is giving us all a rare, and sometimes chilling, glimpse. Prepare yourself for what lies ahead.

JOSHUA P. WARREN
Author of *Haunted Asheville* and *The Evil in Asheville*
Owner of the Haunted Asheville Ghost Tours
www.HauntedAsheville.com

# ACKNOWLEDGEMENTS

The years 2017 and 2018 presented a steady flow of challenges, so it somewhat boggles my mind that I was able to fit writing a book into the mix. I received so much love and support from my family and friends and thank them so much: my two children, Ben and Hannah; my dad, Ray Hardee; my maternal aunt, May Shuford; and my lifelong friend and encourager Donna Morgan Green and a more recent friend and great supporter Jan Schochet, who sent me jars of Epsom salt and Mexican dark chocolate when I needed to recharge. There also are many friends who offered support in a myriad of ways, but if I start naming everyone, I'm likely to miss someone, and that would be disappointing. My heart is overflowing with gratitude to all who have helped me and supported my work.

I owe a world of gratitude to the staff at the N.C. Room at Pack Memorial Library in Asheville. Zoe Rhine, Lyme Kedic, Ione Whitlock and Ann Wright provide expert assistance as well as friendship and lots of laughter.

Katie Wadington, executive editor of the *Asheville Citizen-Times*, really went out of her way to dig out several photos from the paper archives and to grant me permission to include the images in this book. I am so grateful for her assistance as well as her friendship.

Joshua P. Warren has become a mainstay in my books, as he's generously provided me with many stories and quotes. For this book, I'm extremely appreciative that he agreed to write the foreword. His schedule is mind-boggling, so the fact that he agreed to participate means the world to me.

He's an Asheville native with generations of his family going back for hundreds of years in these mountains. He's also an internationally acclaimed paranormal researcher/investigator, author, radio host and husband to the lovely Lauren.

Karri Brantley is the magician behind the camera who captured my author photo. I became aware of her talents while writing my second book—at that time she graciously allowed me to reprint her photo of Mike Harris holding the guitar Elvis Presley gave him during an Asheville concert. Karri is fun, fabulous and a very talented photographer. You can find her at karribrantleyphotography.com.

I also extend thanks to those people who agreed to interviews for this book:

Jon Elliston
Ray Hardee
Ronda Stewart Hawk
Steve Hill
Steve Lindsay
Brandi Quinn

I am very grateful to The History Press for allowing me, once again, a chance to write a book about my hometown: Asheville, North Carolina. I am thankful for the kind assistance of Chad Rhoad, the commissioning editor, and Abigail Fleming, who copyedited this book.

# INTRODUCTION

*All things truly wicked start from innocence.*
*—Ernest Hemingway*

I'm not sure how my writing on Asheville evolved from the fun quirky first book *Only in Asheville: An Eclectic History* to the more mysterious *Legends, Secrets and Mysteries of Asheville* to this book—*Wicked Asheville*. While I didn't anticipate it when I proposed writing this book, I have witnessed the national tone changing in an eerily parallel way to include more of the things I consider wicked: increased injustice, blatant hypocrisy and rudeness and disrespect for others.

The news has been filled with a plethora of sexual harassment cases brought out in the open; white supremacists carrying torches in Charlottesville, Virginia, while shouting such things as "Jews will not replace us," "Blood and soil" and "White lives matter"; anger among some about a football player taking a knee during a national anthem to peacefully protest police brutality against people of color; mass shootings like the one at a high school in Parkland, Florida, on February 14, 2018, which claimed the lives of 17 people, followed by the ongoing debate about gun control; claims of "fake" news and the separation of families at the border. These are just a few examples of current events in the tense, divided climate of the United States as I write this book.

As with my other books, I have chosen stories that I'm most interested in researching, so I delve into historic events as well as more recent

happenings. I have a personal connection with several of the stories in this book: I grew up in Skyland United Methodist Church and watched siblings Zebb and Brandi Quinn grow up in this church. I know this family and I know firsthand of Zebb's goodness and strong character. I was the morning/noon producer at WLOS-TV when anchor Karen Coulon faced trial on arson charges, and I was hired by criminal attorney Stephen Lindsay to assist with the corruption trial of former Buncombe County sheriff Bobby Medford. All of these connections and experiences have led to this moment when I'm tying them all together in a book.

I have also included stories of shocking murders, arson, sedition, corruption, disease and other unsettling tales related to Asheville. Writing this book has challenged me, made me second-guess my topic choice and kept me awake at night. In contrast, it's also given me a greater awareness of the need to learn from history lest it should repeat itself and to also appreciate all that's good in Asheville and in the world. I'm happy to say the good definitely outweighs the bad.

May we all choose to be a blessing to one another through our words and actions.

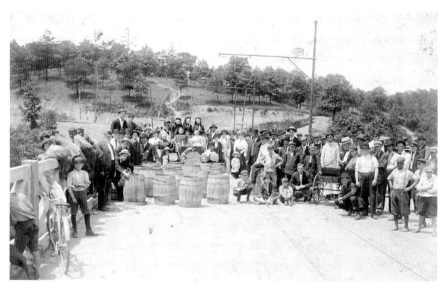

Right as we were going to press with this book, Angela Brown Miotto walked into the N.C. Room at Pack Library in Asheville and donated some wonderful prohibition photos. Her grandfather Charles Nelson Lominac served as chief of the Asheville Police Department from 1914 to 1915. This photo shows a gathering after the vote to approve prohibition—the women took charge of making sure that barrels of illicit liquor were dumped in the river. *North Carolina Collection, Pack Memorial Library, Asheville, North Carolina.*

# I

*Murder and Mayhem*

# 1

# THE NIGHT EVIL
# CAME TO TOWN

*They took that ghastly mutilated thing and hung it in the window of the*
*undertaker's place for every woman, man and child in town to see.*
*—from "The Child by Tiger" by Thomas Wolfe, a fictionalized version of the*
*Will Harris murders*

I've always had a romantic notion of what life in Asheville was like in the early 1900s. George Vanderbilt was living in his massive castle, known as Biltmore, with wife, Edith, and daughter, Cornelia. Many skilled European artisans, hired to craft different aspects of Vanderbilt's estate, stayed in the area and lent their talent to other impressive projects around town. The first Battery Park Hotel hosted a steady stream of well-educated and financially successful tourists—many were drawn to the area because of its fame as a top tuberculosis center. And Thomas Wolfe was a young boy, growing up in his mother's boardinghouse with a constant flow of strangers sharing his space.

It all sounds pretty inviting—a town filled with wealth, high society, and a close-knit community of citizens. But in November 1906, *evil* came to town. His name was Will Harris, an African American desperado from Charlotte who had escaped from his prison cell in Raleigh in 1903 after serving only three months of a twenty-five-year sentence. He was convicted on charges of burglary, larceny and assault. Harris was assigned to a work detail making and loading bricks. It's believed he shipped himself out of the prison with a load of the bricks that had not been fully inspected.

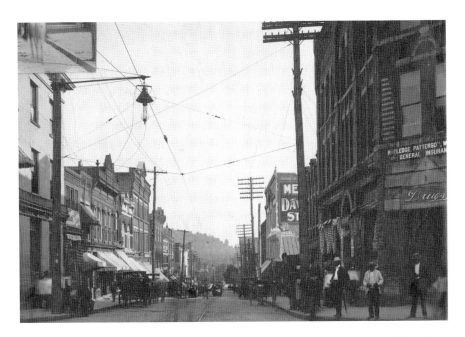

A glimpse of what downtown Asheville looked like in 1906, the year Will Harris killed five men during a twenty-minute rampage. *North Carolina Collection, Pack Memorial Library, Asheville, North Carolina.*

With his newfound freedom, he made a beeline to to see Pearl. She was the woman he previously lived with; they had two children together. When he got to her Charlotte home, he found out she had married a man named Sam Huey two months earlier. When he encountered Huey, Harris pulled out a gun and tried to kill him, but he only wounded him. Once Harris spent all his ammunition, he fled on foot, leaving the Hueys and the community terrorized.

At the time of Harris's escape, the governor offered a $200 reward, and Mecklenburg County officials called on all its citizens to take Harris "dead or alive." The proclamation assigned the right to any resident of the county to call upon Harris to surrender if they came into contact with him. If he refused, officials said any citizen was permitted to "shoot him in cold blood and the law will hold him guiltless." A report in the *Charlotte News* said, "It is the belief of both the city and county officials that Harris is still in the county and the belief also that he will continue to dodge around Mecklenburg for some time to come, unless his dodging is forever stopped by some good citizen, handy with a gun."

He managed to elude capture for three years before showing up in Asheville.

# NIGHT OF TERROR

Harris had some shopping to do when he arrived in town on November 13, 1906. He plunked down thirty-two dollars for a pair of blue overalls, a suit, shoes and other items at Swartzberg & Son at North Pack Square. He then paid a visit to Finkelstein's pawn shop, picked out a .303 Savage rifle and bought a box of cartridges. Add a quart of whiskey from a local saloon into the mix, and he was primed for a night of terror unlike anything Asheville had ever experienced.

He asked around town for directions to where Mollie Maxwell lived. He found her apartment on Valley Street, but Mollie wasn't there. Her sister, Pearl, was. (Note: *I first questioned whether this Pearl was the mother of his children, but I can't find any connection between the two women.*) Harris ordered her to make him dinner, and he continued taking sips of whiskey. An hour later, Pearl's boyfriend, Toney Johnson, came to the apartment. He knew of Will Harris and recognized the situation could quickly turn volatile—Harris was sitting with the rifle across his lap. Johnson sprinted to police headquarters on the east side of Pack Square, where he found Captain John R. Page and patrolmen Charles Blackstock and James W. Bailey. As Johnson cried out his plea for help, Page and Blackstock took off and headed to the apartment. Page ran to the back to prevent Harris from escaping while Blackstock approached the front door. Harris was ready. He fired through the door, killing Blackstock. Page heard the shot and ran to the front, where Harris shot him in his right arm. Page frantically raced back to headquarters for help while Harris took his rage outside. He went up Eagle Street, yelling, "MY NAME IS WILL HARRIS. I'M A MEAN SON OF A BITCH."

Page burst through the doors at police headquarters and shouted to Bailey to round up other people to help put an end to the terror.

Harris stayed on the move. He made use of his rifle, firing at everyone in sight. The first person he happened upon was Ben Addison, owner of a little grocery store at 52 Eagle Street. The bullet Harris fired passed through Addison's right eye. His body was silent and unmoving when it hit the ground.

Tom Neal was standing with three friends near the intersection of Eagle Street and South Main when he turned to see where the sound of gunfire was coming from. He spotted Harris firing and thought it was a prank. Then he felt the pain ripple through his body. Harris shot him without warning. A newspaper account written by the late famed Asheville writer Bob Terrell said, "The ball struck a silver quarter in Neal's pocket and smashed upward through his body, driving shards of bone into his bladder. Neal staggered

back and fell on the step's of a doctor's office. When found, he was rushed to the hospital but died on the operating table."

Up on South Main Street, as Harris continued his drunken crime spree, the bartender at Laurel Valley Saloon stepped outside to see what the commotion was about. Harris fired at him—the bullet cut through the barkeep's pants but somehow missed his flesh. He fled. Harris fired at will—it's said there are nicks on the Vance Monument from the gunfire on this night in 1906. On College Street, he killed a third black man.

Bailey had quickly deputized a few citizens he found, and one ran to ring the fire bell to alert the rest of the town to the danger. The others ran to find guns as Bailey headed toward the sound of Harris's rifle exploding. Bailey leaned up against a telephone pole in front of Asheville Hardware, trying to conceal himself until he could get a clear shot. The two men exchanged gunfire, and Bailey ultimately died when he took a hit to the head that went through the pole. Harris took off running to Biltmore. In the span of just twenty minutes, he had claimed the lives of five men, including the two Asheville police officers who died in the line of duty. Stunned townspeople didn't know what to do. Thomas Dixon Jr. was in the British-American Club when the rampage happened. He said of the incident:

> *Never did it seem to me that a beautiful city like Asheville was so helpless. It was almost an hour before organized pursuit was on the trail of the murderer. Not that there was not willing men ready. On all sides were men eager to avenge the murder of the brave policemen who fell on the post of duty. But in that hour of need there was neither arms or ammunition. After much parleying the Asheville hardware company door was forced and the search for arms commenced.*

## ON THE RUN

Fire Chief Silas Bernard, who raced to the scene upon hearing the fire bell, called on the men gathered in the square to form a posse and go after Harris. Few were armed, so the immediate problem they faced was finding enough guns and ammo to hand out to the crowd. Harry Finkelstein at the pawn shop volunteered his supply and handed out dozens of guns and revolvers.

Chief Bernard ordered a break-in at the Asheville Hardware Company in order to retrieve more rifles, shotguns and revolvers for the crowd. He also

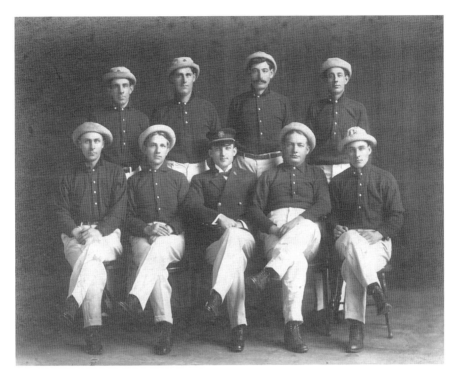

Fire Chief Silas Bernard is seen in the black cap in the middle of the front row. *North Carolina Collection, Pack Memorial Library, Asheville, North Carolina.*

offered a reward of $500 for the capture of Harris. It quickly rose to $1,200 by private donations.

A blinding snowstorm hampered the posse's efforts, along with the vague description of Harris. Many only knew they were searching for a black man. Despite the obstacles, they caught up with the desperado two days later in Fletcher. Harris was hiding in a barn and ready to fight, spewing his remaining ammunition at the posse. There were at least one hundred men on hand at that barn, and they riddled Harris's body with bullets. It was just after noon on February 15. Around 2:30 p.m., they returned to downtown Asheville with the body loaded in a wagon.

The posse took the body to the undertaker, where it was identified by Mr. J.R. Roberts, a clerk at Swartzberg & Son who sold him clothes, and Harry Finkelstein, who had sold him the rifle. A crowd of Asheville residents gathered outside and demanded to see this man who had terrorized the town and killed two officers. Officials feared the mob would overpower the scene,

take the body and burn it, so they decided to hold a public viewing and propped the body up in the undertaker's window to allow folks to take a look at evil in human form. Noted author Thomas Wolfe, who was a child at the time, eventually wrote about Harris's night of terror and the public viewing of the body in his short story "The Child by Tiger."

The posse unanimously agreed to give the reward money to the widows of Patrolmen Bailey and Blackstock. They also voted to give Harris's rifle to Captain Page of the Asheville Police Department.

Superstition caused the APD to permanently retire Officer Bailey's badge. The mass murder happened at 13 Biltmore Avenue on November 13, and Bailey's badge was number 13.

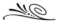

# A QUICK NOTE ABOUT PROHIBITION

Multimillionaire John A. Roebling joined the posse and carried a $1,000 Mauser rifle in the hunt for Will Harris. Second only to George Vanderbilt, Roebling was the city's largest taxpayer. He was the owner of Beauxchenes, a $500,000 estate on St. Dunstan's Road. The year after Harris was killed, Roebling left his estate to the home mission board of the Northern Presbyterian Church and retreated to New Jersey. He left because Asheville went with prohibition, which he vehemently opposed.

Left to the town's men, Asheville might not have gone dry beginning in 1908. But the women and children had a heavy hand in influencing the vote, even though they couldn't cast ballots themselves. The day after the October 8, 1907 vote, the *Asheville Citizen* reported:

> *Seizing the polls at daylight, active, alert, well organized, the women and children absolutely captured the city and there never was a moment from daylight to dark when they did not dominate the situation. As a demonstration of their resistless power yesterday's election will be a monument. Singing, praying, cheering, hundreds of them at polling places blocked the streets and swept in a stream of votes as resistless as the Atlantic tides.*

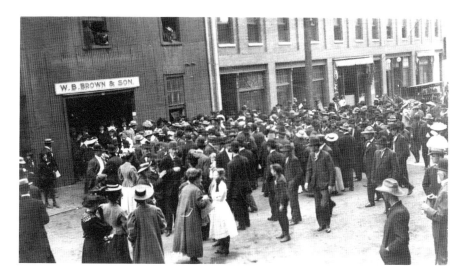

Crowd gathered in downtown Asheville for the prohibition vote. Women couldn't cast ballots, but they had a lot of influence over the men as they took to the streets to force a "yes" vote. They are shown here on College Street. *North Carolina Collection, Pack Memorial Library, Asheville, North Carolina.*

Those on the anti-prohibition side didn't anticipate that men who promised to vote *no* would yield to the pressure. Others simply couldn't vote, as they were blocked out. "The ladies won the election," said John O'Donnell, "and it wasn't you men."

Will Harris's drunken murder spree may well have played into the women's action to force prohibition. In a speech by Judge J.C. Pritchard on September 29, 1907, he urged listeners to vote for prohibition:

> *Asheville, according to her opportunities, is about as wicked as any city of which I have any knowledge and while we have many other evil agencies in our midst, nevertheless, the sale of whiskey is responsible for nine-tenths of the crime, which has recently been committed in this vicinity. Within the last months a number of murders have been committed within our city limits and I believe that in every instance these unfortunate affairs were directly traceable to the use of whiskey. Some of the brightest and ablest young men of Asheville have been absolutely ruined by whiskey.*

## 2

# MURDER AT THE
# BATTERY PARK HOTEL

*I called her name and still she did not reply....My thought was to take hold of*
*the knob and shake it and maybe wake her so I took hold of it and it swung and*
*there she was in that posture....I said "Oh, it is awful! It is awful!"*
—*W.L. Clevenger*

When eighteen-year-old Helen Clevenger checked into the
Battery Park Hotel in Asheville in the summer of 1936, her mind
whirled with the possibilities for her future. She was a New York
University honor student and was on a tour of southern universities when
she arrived in Asheville. Her parents, J.F. and Mary Clevenger, remained
at their home in Staten Island, New York, and most likely worried about
their only child but felt confident placing her in the hands of her fifty-one-
year-old bachelor uncle, W.L. Clevenger, who was a professor at NC State
University. He served as chaperone for Helen during her travels in North
Carolina. Clevenger taught animal husbandry and dairying at the college
and also worked with the agricultural extension service.

Even though her room wasn't on a higher floor with sweeping views of
town and the surrounding mountains, she surely appreciated the comfort
and luxurious amenities of the hotel. It actually was the second Battery Park
Hotel on the site. The first opened in 1886, but E.W. Grove of Grove Park
Inn fame ultimately razed it in the early 1920s. The second incarnation of
Battery Park Hotel—the one Helen Clevenger stayed in—opened in 1924
and featured 220 rooms, fourteen floors, a rooftop dining area, a lounge

The Battery Park Hotel in Asheville where Helen Clevenger was murdered. *North Carolina Collection, Pack Memorial Library, Asheville, North Carolina.*

and open terraces to view the gorgeous scenery. Tragically, Helen's life was snuffed out in a savage fashion in this upscale place.

On the evening of July 15, 1936, sheets of rain pelted against the windows at the Battery Park Hotel as thunder crashed through the heavens. Guests would later report hearing a woman screaming around 1:00 a.m. on July 16, but no one remembered hearing the gunshot that killed Helen. Her

Murder victim Helen Clevenger was murdered in room 224 of the Battery Park Hotel. *North Carolina Collection, Pack Memorial Library, Asheville, North Carolina.*

uncle was staying in room 231 and went to her room—number 224—around 8:30 a.m. to wake her. His room was around the corner from his niece's room and located past the elevator and stairwell. Shock flooded his body when he came upon the scene—Helen's body was slumped in the floor near the door to her room. She was on her back with her legs doubled beneath her. Her left hand was on her chest, and her right arm was curled above her head. Blood from a gunshot wound to the chest stained her green-striped silk pajamas. Her face was badly bruised and mutilated from being bludgeoned and slashed.

She was noted as "a pretty blonde" in newspaper accounts, so did someone spot her in the lobby upon check-in and ultimately get mad when she rejected his interest? Could someone have been following her? Or was she the target of a thief? In its day, the Battery Park Hotel (which now serves as apartments for elderly residents) was known as a high-class tourist destination. Any number of guests would have many valuables that could draw the eye of a would-be robber. Was it her age and the fact that she was staying in a room alone that made her more vulnerable? Or could her death have been the case of mistaken identity (or mistaken room)? Could she have died at the hands of her uncle? These are just a few questions that come to mind as one ponders her brutal fate.

Clevenger and his niece first arrived in Asheville on July 11 and stayed on the third floor of the Battery Park Hotel and then checked out. They returned to the Battery Park Hotel on July 14 and this time were assigned to the second floor. This timeline is taken from Clevenger's court testimony. The court asked him: "You said room 330 and 324. Don't you mean 231 and 224?" Clevenger answered: "No, I am talking about the first stop we made.

Sunday morning we left for Newfound and on down to Topton, Murphy. We stopped at the Durkey House with Mrs. Durkey. On Monday morning we left and stopped at Brasstown and at Mr. Slagle's at Franklin and spent the night and were there until Tuesday after dinner."

They checked back into the Battery Park Hotel around 7:00 p.m. on July 14, and they were assigned to the second floor, even though Clevenger said in his testimony he had asked to return to their previous rooms on the third floor. The next day, they drove to Marshall to attend a farmers' meeting and returned in late afternoon. In the evening, they visited with C.W. Pegram, a longtime friend of the professor who lived in Fairview. After their visit, they returned to Asheville around 10:00 p.m. and were back in their respective hotel rooms by 10:30 p.m.

Helen spent some time that evening writing in her journal. Officials found her diary but noted it didn't contain any mention of a boyfriend or any romantic interest. She also had rinsed out her undergarments and hung them to dry in her room—a clue that she wasn't expecting any company that night. Whether she was awake and still writing when the intruder barged into her room is up for speculation, but if she was writing, her light would have been on. If someone was coming in at 1:00 a.m. to rob her, why would he or she do so if light was shining through the crack of the door? If the lights were out when the intruder came in, why wouldn't he simply flee when she called out in fear? It seems likely that in the dark, along with her shocked state, it would have been difficult for her to give an accurate description if the assailant had simply fled. Police confirmed that no robbery occurred—the twelve dollars cash she had was still in the room, along with her watch.

On August 2, 1936, the *Asheville Citizen-Times* reported about the state of her room:

> *Apparently the girl disrobed, took a bath, washed her underclothing, wrote briefly in her journal (or diary), wrote a post card to her parents, Mr. and Mrs. J.F. Clevenger, and possibly read one or both of the two magazines in her room. Her bed had been turned down, her handkerchief tucked under her pillow, but she had not slept in the bed. It showed no signs of a struggle having taken place on or near it.*

All these years later, the story of Helen Clevenger's murder remains one that's often repeated in Asheville. For instance, Joshua Warren's Haunted Asheville ghost tour takes patrons to the rear of the Battery Park Hotel and points out the window of Helen's room. Guides provide a dramatic account

Battery Park Hotel employee Martin Moore was convicted and executed for the 1936 murder of Helen Clevenger. *North Carolina Collection, Pack Memorial Library, Asheville, North Carolina.*

of the horrors that happened that night. It is common knowledge that Helen was murdered and a hall boy named Martin Moore confessed to killing her in a botched robbery attempt. He was convicted and died in Raleigh's gas chamber six months after the crime took place. Sounds pretty cut and dried, yet the story is much more complicated. Digging into the details of that night and the subsequent investigation produces more questions than answers.

## FOLLOWING THE CLUES

When W.L. Clevenger arrived at his niece's door on the morning of July 16, the door was unlocked. Investigators recovered a hotel pass key that was still penetrating the lock on the outside. The regular key to the room was found, bloody and lying underneath the radiator.

Authorities ran fingerprint tests on the key found in the lock as well as various objects in the room but could not find any useable print.

A report in the July 23 issue of the *Asheville Citizen* revealed the key found in the lock was a mysterious "twelfth key":

*There were supposed to be 11 of these keys out, all of them master pass keys that would open a guest room even though it was locked from the inside and the guest's key in the lock. The 11 keys were in the possession of the persons to whom they were issued. The twelfth key, Sheriff Brown says, was used by the murderer to open the door to Miss Clevenger's room. Just how he obtained it no one knows. No explanation has been offered how there were 12 keys when only 11 were supposed to be in existence.*

Other reported clues included the following:

- A rusty .32-caliber bullet made for a German-type automatic.
- The shell had an H and three stars on the rim.
- Investigators said no such ammunition had been sold in Asheville for the past ten years.
- A ten-inch, nickel-plated paper knife found in the hotel manager's office.
- An ice pick and pair of scissors taken from a search of musician Mark Wollner's home.
- Helen's diary, which officials examined for clues to see if there were love interest or any fears of threat. They found nothing.
- Bloodstains on the upholstery of a chair in her room.
- Some fingerprints were found on objects around the room, but the sheriff said they were "practically valueless."
- No indication of rape or attempted rape, as noted by the mortician.
- At least ten people heard Helen screaming. They were guests in rooms above, below and to the right and left of her room.
- No one heard the gunshot that killed her.
- The hotel lobby only received one call about the screams.
- At least four people saw suspicious people lurking in the halls of the hotel or running from the lobby of the building.
- Strands of hair found on a towel in Helen's room were taken to the Federal Bureau of Investigation in Washington for comparison with a hair sample from Daniel Gaddy, night watchman. Investigators said they did not match.

## OTHER STRANGE OCCURRENCES

Police extensively interviewed guests who were staying in the hotel that night. They received a couple of strange stories. McGrady Richeson of Charlotte said someone knocked on the door of his room early in the morning of July 16. He was staying in room 421. When he opened the door, he said he saw a short and husky man of about twenty-five to twenty-eight years of age dressed in sport clothing standing across the hall in front of room 424. Richeson said as he opened his door, the man took off running in the direction of the elevators. Hotel records show room 424 was unoccupied the night of the murder and was situated two floors directly above Helen's room.

A man identified as J.J.J. Cox was staying in room 218. He left his room door open to hopefully create a cooling draft because it was a very hot and humid evening. He said when he woke the next morning, his door was closed and locked. He had no explanation for how that happened and never heard any unusual noises.

## EVERYONE IS A SUSPECT

Sheriff Laurence E. Brown certainly felt the pressure of securing a prompt arrest in this high-profile case. Word spread like wildfire in Asheville. To put into context the flavor of the town in the summer of 1936—F. Scott Fitzgerald was holed up at the Grove Park Inn trying to write. He also transferred his wife, Zelda, to nearby Highland Hospital. Biltmore House was open for tours in 1936—Cornelia Vanderbilt Cecil and her husband, John Cecil, first welcomed paying guests to the estate in 1930 as a way to help the local economy. Julia Wolfe, Thomas Wolfe's mother, was running her boardinghouse, which would have been bursting with speculation about the murder. My dad was six and a half years old in the summer of 1936 and vividly remembers people talking about the girl who was murdered at the Battery Park Hotel. News of the tragedy also traveled around the country via national news coverage and through the dramatic retelling in *True Detective*. It's likely Brown received a good bit of pressure from the tourism officials in Asheville, who may have feared visitors changing travel plans if they deemed Asheville hotels unsafe. Having a killer behind bars would relieve the anxiety. Reward money totaling $1,000 for information leading to the capture of the killer came in reportedly "$200 each by the city, county, state, Asheville

Hotel Men's association and the North Carolina Hotel Men's association." At this point, Brown had to consider everyone a potential suspect—from hotel employees to other guests and Helen's uncle, as well as someone who might have entered the hotel in the night.

Quite a few people were targets of Sheriff Laurence E. Brown's detention and questioning before Martin Moore ever came into view as a suspect. Until I began my own investigation of Helen's death, I had never heard about an internationally acclaimed violinist who was jailed as a suspect in this case. Thirty-five-year-old Mark Wollner of Germany came to Asheville a year or two before Clevenger's murder and had a studio located across the street from the Battery Park Hotel. His estranged wife, twenty-nine-year-old Mary Bowen Wollner, served as a language teacher at the National Cathedral School for Girls in Washington, D.C., and their four-year-old daughter lived with her. Wollner studied music in Berlin and Paris and had previously lived in New York and Washington, D.C. The *Chicago Tribune* reported on July 19, 1936, that "Wollner, who has played difficult transcriptions of Bach, Franck, and Mozart on three continents was arrested last night after officers announced a 'prominent white man' was sought." The article went on to say, "The sheriff said he had been informed by a witness, whose name he did not reveal, that Wollner had remarked about 10 p.m. Wednesday, 'I've got a date with a girl at the Battery Park Hotel tonight.'"

E.B. Pittman, a state banking department employee from Raleigh, who was staying in the room across from Helen's on the night of the murder, reported that he went into the hallway after hearing screams around 1:00 a.m. He said he exchanged a few words with a shadowy form in front of Helen's door, one that he thought was another guest in the hotel. The sheriff sent Pittman to the Grove Park Inn on Friday, July 17, where Wollner was playing to see if Pittman could identify him. He reported that Wollner's build seemed consistent with the figure he saw but that he felt Wollner's voice had a higher pitch. On Saturday, July 18, the sheriff held Wollner for questioning. Shortly after he was jailed, the county physician Howard L. Sumner examined Wollner in his cell and observed a fresh cut across the toes of his left foot. He reportedly had a bruised left heel and strange brown stains on his clothing. An eyewitness had reported seeing a man vault over the front wall of the hotel in the early morning hours when Helen was killed—a high drop that more than likely would have caused physical injury.

Wollner told officials he had arrived home at 9:30 p.m. on June 15 and stayed there until leaving at 8:30 a.m. on June 16. His alibi was backed up by nineteen-year-old Mildred Ward, the tubercular daughter of his landlady.

However, testimony from other witnesses challenged his assertion that he had been home. The *Cumberland (MD) Evening Times* published a timeline of witness reports, which said a café owner reported Wollner finishing dinner the night of the murder around 10:00 p.m. The article goes on to report the following:

> *Between 10 p.m. and 10:30 p.m....Doug Eller, an Asheville reporter, saw Wollner drinking beer. At 2 a.m. the sheriff said a girl witness saw Wollner on the streets. At 6 a.m., Charles English, 19, noticed the musician drinking coffee at a lunch room....At 6:30 a.m., the officer said Miss Nevada Whitaker and Mrs. Roy Baker, who live next door to the Wards, saw Wollner come home.*

The *Poughkeepsie (NY) Eagle-News* reported, "Sheriff Brown said Nevada Whitaker, 28, a next-door neighbor of the Wards had signed a statement she saw Wollner return home at 6:30 a.m. Thursday. He quoted her as saying Wollner knocked on the window of Mildred Ward's room and then went up the back steps of the house." Whitaker added that Wollner "walked with difficulty as though he had been injured." She reported he left the house five hours later carrying a pair of trousers under his arm.

As for the reports of stains on Wollner's clothing at the time of his arrest, the sheriff sent the items to Raleigh for analysis. However, a news article reported the clothing would

> *probably be returned to Wollner shortly without examination. The package containing the sport coat, trousers, shirt, tie, and underclothing [of Wollner] was sent to state chemist W.H. Allen by mail by the sheriff the day after Wollner was taken into custody. No instructions for analysis accompanied the package, and Allen has held the clothes untouched. Wollner was subsequently released and decision of the sheriff to return the clothes unexamined marked the collapse of another angle in the baffling murder mystery.*

Brown released Wollner on July 24 and jailed another suspect—Helen's uncle W.L. Clevenger. Brown questioned him for four hours and then locked him up, but charges were not filed. The sheriff told reporters, "I had hoped to have a confession for you newspaper boys tonight, but it may be a week or 10 days due to new developments." Clevenger had just returned to Asheville after attending Helen's funeral in Fletcher, Ohio.

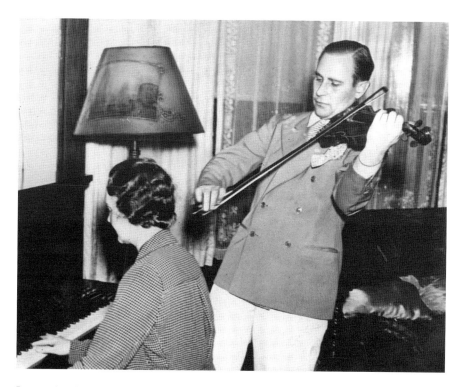

Internationally acclaimed violinist Mark Wollner was jailed for questioning in the murder of Helen Clevenger when his alibi was disputed. He's seen here with his accompanist, Mary Brooks, whom he later married. *North Carolina Collection, Pack Memorial Library, Asheville, North Carolina.*

At that time, two Battery Park Hotel employees also remained in custody: Daniel Gaddy, the night watchman, and L.D. Roddy, elevator operator. Gaddy failed to punch his time card in the corridor outside Helen's room as scheduled at 1:00 a.m., but Brown said he didn't suspect him of the crime. The sheriff kept Gaddy detained in hopes he could remember additional details. Brown reported questioning seventy-five employees in hopes someone would have a key piece of information.

## THE REAL KILLER?

A break in the case came in early August when authorities detained Banks Taylor, a hotel pantry boy, for questioning. Taylor reportedly pointed

authorities in the direction of Martin Moore, saying he recently came into possession of a pistol. The sheriff took Taylor to Moore's home and confronted him with the information. He said Moore first denied it but ultimately led him to the pistol beneath some plumbing under his house. A newspaper report claims "the pistol, the sheriff said, was a heavy .32 caliber Spanish 8-shot automatic, fully loaded. [*It's important to point out that earlier in the case, authorities had identified the gun as a German automatic.*] The sheriff said the butt was stained with blood and blonde hairs clung to it. He said the [bullets] in the cartridges were identical with that taken from he body of the pretty honor student."

On August 9, Sheriff Brown formally announced the arrest of Moore. He said the twenty-two-year-old African American hall boy had confessed to killing Helen Clevenger and reenacted the crime for investigators. The sheriff said Moore told them he was bent on robbery when he entered room 224 after finding two other doors on the same floor locked.

This information seems strange in light of the fact that Brown had earlier told the press that the discovery of a pass key in the outside lock of Helen's room was the strongest clue. If Moore was in possession of the mysterious twelfth pass key that could open any door in the hotel, why would there be a mention of passing locked doors? If Moore was coerced into a confession, he may not have known the killer used a pass key to gain entrance, and his "confession" of bypassing locked doors wouldn't have rung true.

Sheriff Brown seemed to have an answer for this discrepancy. A newspaper report said, "The sheriff, in light of the confession, said the master pass key found in the door after the body was discovered probably was placed there unwittingly by some one, who later perhaps preferred not to mention it for fear of being connected with the slaying."

News reports say Moore was quoted by the sheriff as saying his motive was robbery:

> *Miss Clevenger was sitting on the bed when I entered....Then she got up and said "What do you want?" I told her that I thought the room was unoccupied. "If you do not leave this room I will call the police," she said and came toward me. I pulled a pistol from my vest and she was within 18 inches of me when she apparently first noticed the gun. She screamed and I fired. As she fell I struck her in the face with the butt of the pistol and fled.*

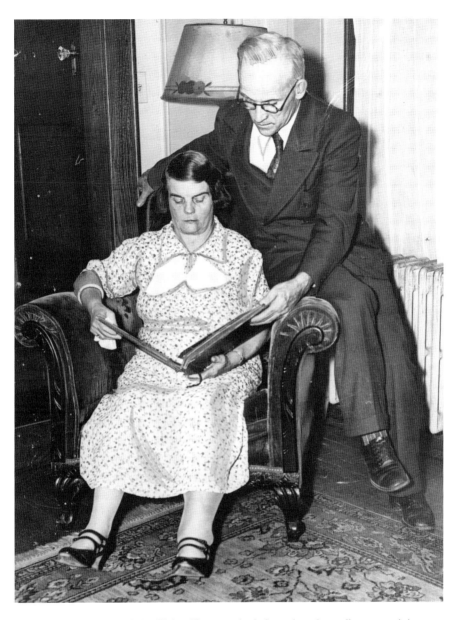

The parents of murder victim Helen Clevenger look through a photo album containing pictures of better days. *North Carolina Collection, Pack Memorial Library, Asheville, North Carolina.*

# TRIAL BEGINS

Perhaps a random tourist arriving in Asheville during Moore's trial might not have been aware of what was transpiring despite the national news coverage, but it was certainly the buzz among all the locals. A newspaper report summed up the swirling speculation and doubt that officials had the right man:

> *In the hotel lobby, in the cafes, on the streets, natives would talk cautiously, then throw up a defense barrier of "I don't know. It all is such a mystery!" They fear possible questioning, even now, and yet they have misgivings and grave doubts. Some say they believe Moore killed in a frenzy of excitement when he found upon entering the room the girl, pajama clad, awake, in fear that she might talk if she lived. Others believe that if Moore did the gruesome job, others were accessories before or after the fact. The average Ashevillian clings to the belief that Gaddy, night-watchman, liberated when Moore was arrested, knows something he has not told. His time clock, located on the death floor was not punched at the hour fixed as the death hour about 1 o'clock on the fateful morning.*

According to a map of the second floor published in the *Asheville Citizen-Times* on August 2, 1936, the time clock station was just a few feet outside Helen Clevenger's door.

During the trial, defense attorneys put Moore on the stand in order to have him detail under oath that he was beaten into a confession. A written account in the *Asheville Citizen-Times* provided the exact line of questioning and answers:

> *Moore: They started beating me.*
> *Attorney: Who did?*
> *Moore: This fat man started beating me with a dark hose.*
> *Attorney: What kind of hose was it?*
> *Moore: It looked to be a water hose.*
> *Attorney: Just an ordinary hose?*
> *Moore: Yes*
> *Attorney: Where did they beat you?*
> *Moore: Across my arm and across my shoulders.*

Moore pointed out where he had been hit to the jury and said the assaults continued over a period of time. He claimed he confessed because

he feared more beatings. He also told the court that he had told the men that he had loaned his gun to a man named L.D. Roddy, who was a bellhop at the hotel, and that it was in Roddy's possession at the time of the murder. He claimed that Roddy returned the gun to him the day after the murder. Testimony reveals investigators lied when they told Moore they found his fingerprints on the lampshade in Helen's room. In reality, officials knew they didn't have any useable print.

It took the jury of twelve white men only an hour to return a guilty verdict against Moore on August 22, 1936. He was sentenced to die in the state gas chamber. Moore's sister burst into tears on hearing the pronouncement, but Moore didn't display a reaction. Judge Don Phillips said "Martin, have you anything to say?" He sat with arms folded across his chest and simply shook his head in the negative. Even though Moore had denied his confession, the jury said the confession was valid and "conformed to facts known about the crime prior to Moore's arrest." Defense attorneys appealed the decision, but it only slightly delayed his scheduled execution. He was originally slated to be put to death on October 2 but ultimately died in the gas chamber on December 11, 1936. He was declared dead twelve and a half minutes after he entered the death chamber. He continued to plead his innocence until his last breath. Jailers said he spent his last hours reading a prayer book. Before being led from his cell, he was joined by two ministers in singing "Pass Me Not, O Gentle Savior."

Booker T. Sherrill served as bell captain at the Battery Park Hotel from the 1930s until it closed in 1972. He stayed there, living as a resident in the Battery Park Apartments until he died on October 30, 2003. His oral history is archived at UNCA and includes his thoughts about the murder:

> *I was off duty during the time of the 1936 murder and was not questioned, but there were some bad feelings about this. Some think it was never solved. Some think the son of the manager was to blame. It upset this city and it took eight to ten years for the people to relax. Room 224 was permanently blocked. Although I kept my thoughts to myself, I don't think Moore, a relatively new night janitor, had the mentality to commit the crime.*

# WHATEVER HAPPENED TO WOLLNER?

Wollner, free from police scrutiny despite the red flags associated with his behavior and injuries from the night of the murder, began a romance with

Mary Brooks and moved to Hendersonville. He met Brooks in 1936, the year of the murder, when he played a recital in Asheville and she was hired as his accompanist. They did not marry until 1961.

In addition to being a violinist, he was an accomplished artist working primarily in watercolors. A report in the April 14, 1963 issue of the *Asheville Citizen-Times* said, "Mark Wollner, who spends part of each year in Hendersonville, the home of his wife, the former Miss Brooks, has established a studio for art and music on the west coast of Jutland, Denmark, near Esbjerg. Each summer students gather there to work."

In 1966, he held a one-man show at the Flat Rock Playhouse gallery featuring twenty paintings covering 1961 to 1966 and including almost every medium. An article promoting his show referred to Wollner as having "a delightful personality, simply oozing with continental charm."

Was Wollner the real killer of Helen Clevenger? Or could it have been the manager's son who would have had more access to the emergency pass key? Was an innocent man put to death, or was Moore the real killer? And where was the night watchman, Daniel Gaddy, when he failed to punch his time card near the time of Helen's death? The mystery remains.

# WICKED TO THE BONE

*Frankly, we don't believe there is any punishment that exists that would be a justification for what he did. We can only hope that he suffers for the remainder of his life on Earth and again as he rots in hell.*
*—statement by the family of murder victim Cristie Codd*

Murders committed at the hands of Robert Jason Owens will go down as among the most heinous and disturbing killings in Buncombe County history. To avoid the death penalty, Owens took a plea deal in April 2017, two years after the deaths of J.T. and Cristie Codd and their unborn child. After the plea hearing, Buncombe County district attorney Todd Williams released a statement, which said, in part:

> *Because there are no surviving witnesses and Jason Owens had exclusive control of the crime scene for several days, and he had nearly completed the gruesome project of cremating his victims' remains, we will never know many of the facts surrounding the Codds' death. What we do know is that through both a solid investigation and a competent interrogation by law enforcement, Jason Owens confessed to being responsible for killing the Codds and further admitted to dismembering and burning their physical remains in a wood stove.*

The judge sentenced Owens to a minimum of fifty-nine and a half years and a maximum of seventy-four and a half years in prison.

Confessed murderer Robert Jason Owens. *From the* Asheville Citizen-Times.

Then, on July 10, 2017, another bombshell dropped: A Buncombe County grand jury indicted the thirty-seven-year-old Owens on a first-degree murder charge in the baffling case of Zebb Quinn. Quinn disappeared January 2, 2000, and Owens was reportedly the last person to see him.

## REMEMBERING THE CODDS

When Joseph "J.T." Codd and Cristie Schoen tied the knot in the fall of 2014, everything seemed to be going their way. They had built careers tied to Hollywood, moved to a house with thirty-six acres on Hookers Gap Road in Leicester and had dreams of creating a self-sustaining hydroponics farm and even opening a farm-to-table restaurant in the Asheville area. They were in love, and friends and family described them as the perfect couple who thrived on helping others and giving people second chances in life. By March 2015, Cristie was five months pregnant with a daughter. They had already picked out her name—Skylar—and prepared to welcome her into their family.

On Sunday, March 18, 2015—the day concerned family reached out to an acquaintance to do a welfare check on the couple's home—forty-five-year-old J.T. was scheduled to report to work in California, where he worked as a grip on movie sets, and Cristie, thirty-eight, was scheduled to provide food through her Tree Hugger Catering company on the set of *The Big Short* in New Orleans, starring Brad Pitt, Ryan Gosling, Christian Bale and Steve Carrell. Cristie rose to fame as a contestant on the eighth season of the TV show *Food Network Star*.

The *Asheville Citizen-Times* reported that Cristie's dad called Cecilia Owens, who had taken care of the couple's house and dogs in the past. She had keys to their house. She also is an aunt by marriage of Robert Jason Owens. She told the paper, "As soon as I walked in, I knew something was wrong. Just the look of the place, and she had left the dogs, and she would never leave her dogs—those were her babies." The dogs were hungry and had used the bathroom in the house. When deputies arrived, they took note of the dogs, the couple's cars in the driveway and an open medicine cabinet where bandages had been removed.

They launched a missing person's investigation and soon received a vital tip. Around 8:30 p.m., a resident took note of suspicious activity at a dumpster on Donna Drive in Candler. Officers retrieved items they identified as being stolen from the Codds and were able to pinpoint Robert Jason Owens as the person who tossed the bags in the dumpster. Deputies interviewed Owens on the morning of March 16 and subsequently charged him with breaking and entering and larceny at the Codds' home. Owens also sold some items belonging to the Codds at two area pawn shops and a flea market. He used some of the cash to take his wife out to dinner at Cheddar's Restaurant.

Owens had completed some home renovation projects on the couple's home and had gotten to know them. Officials received a search warrant to comb through his home and property and found shocking evidence: what

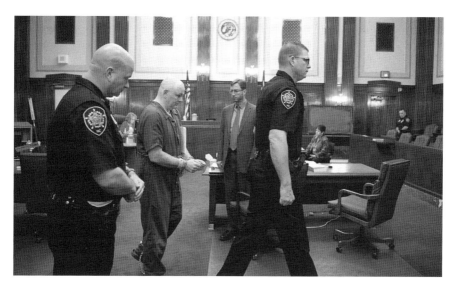

Robert Jason Owens in court at the Buncombe County Courthouse. *From the* Asheville Citizen-Times.

they believed to be human remains in the wood stove. The remains were sent to Wake Forest Baptist Medical Center for confirmation.

During the interrogation, Owens confessed to killing J.T. Codd with a 2008 Dodge Ram truck that belonged to the victim. Owens also told detectives that he stored and destroyed the bodies in his residences on Owens Cove Road. He was arrested and charged with their murders on March 16. Days later, firefighters battled a suspicious blaze on his property. The flames destroyed an unoccupied double-wide mobile home that sat about fifty yards from Owens's primary residence.

Two years later, as Owens took a plea deal to save his life, more information was released about his crimes. He told investigators he accidentally hit the accelerator and ran over the couple as they were trying to get J.T.'s truck out of a ditch. Owens told police, "Then, I backed over them because I knew what I had done." He admitted to investigators that he carried Cristie's body into the bedroom of her home and returned to the scene of he crime to retrieve J.T.'s body. Owens cut J.T.'s body apart with a reciprocating saw and put the remains in a large plastic bag. He went back to the house, dismembered Cristie in the shower and bagged the pieces and fragments. He took their bodies back to a mobile home on his property and burned them in a wood stove.

# ZEBB QUINN'S DISAPPEARANCE

It wasn't like Zebb Quinn to fail to check in with his mother or sister. When he didn't return home on January 2, 2000, they knew something was wrong. His sister, Brandi Quinn, said that in the beginning, officers tried to tell her mother that Zebb was a typical teenage boy and she should let him have some space. But they didn't buy that. Denise Vlahakis raised her two kids as a single mom, and the trio formed a very solid bond. Even though he was eighteen years old and legally an adult, Zebb would never take off without telling them. It simply wasn't in his character to do so. Also, he was looking forward to spring semester at Asheville-Buncombe Technical Community College, where he was enrolled.

"Zebb was such a good person," said Quinn. "He didn't drink. He didn't do drugs. He was a homebody. He wasn't into getting in trouble. I guess the whole thing is a wake-up call to the reality that just because you're good doesn't mean you're safe. People in the community know what a good person

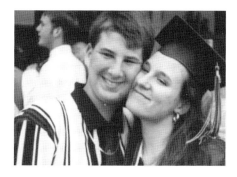

Zebb Quinn and his sister, Brandi. *Courtesy of Brandi Quinn.*

he was, and that seems to be what Jason preys on. Look at the Codds. They were good, wholesome people just trying to be happy and help their community."

Zebb and Jason Owens had been co-workers at Walmart at one point. That's how they met, but Quinn said they were never close friends, as defense attorneys have tried to claim. "The night my brother disappeared, he wanted to buy a car," she said. "Supposedly, Jason was taking him to see the car. The rest of the story is so jumbled. I know a lot of details from the Asheville Police Department, but some I still don't know."

The last known sighting of Zebb was at 9:15 p.m. on the evening of January 2. He was captured on surveillance video at a south Asheville CITGO convenience store. The video showed Zebb and Jason buying sodas. After pulling out of the lot, Owens reportedly told police that Zebb flashed his lights for him to pull over. He said Zebb told him he would have to look at the car later. He had received a page and needed to go find a pay phone. Owens also told police that Zebb returned ten minutes later and accidentally rear-ended his truck. He said Zebb took off after promising to pay for the damage.

In the early morning hours of January 3, Owens showed up at the hospital with head injuries and a broken rib. He claimed he was in a second car wreck that night and told investigators the crash happened near the Waffle House on Long Shoals Road.

A couple of days later, before Zebb's scheduled shift at Walmart, a man claiming to be Zebb called in sick. The supervisor grew suspicious because it didn't sound like Zebb's voice. After the call ended, she hit *69, which revealed the call came from Volvo Construction Equipment, Owens's place of employment. When pressed by investigators, he admitted to making the call, saying he was doing Zebb a favor.

Then it gets even stranger. On January 16, Zebb's Mazda Protegé was discovered in the parking lot of Little Pigs Barbecue on McDowell Street—a stone's throw from Memorial Mission Hospital, where Zebb's mother worked as an registered nurse. A live black Labrador puppy was found inside along with a plastic hotel key and a jacket that didn't belong to Zebb. A pair of lips and exclamation point were drawn in orange-pink lipstick on the

back windshield. The driver's seat was positioned close to the steering wheel, indicating that a person shorter in stature was the last individual to drive the car. Brandi feels that the unusual circumstances of Zebb's car was just part of Owens's game to conceal and throw investigators off his trail. Asheville Police sergeant Chuck Sams adopted the puppy and named her Katie. In a 2012 interview, Sams said, "People have said to her, 'If you could only say what happened, you could solve this whole mystery.'"

Zebb was romantically tied to a woman by the name of Misty Taylor, who had an allegedly abusive boyfriend named Wesley Smith. Zebb reportedly claimed Smith threatened him to stay away from Taylor. Both have denied involvement in Zebb's disappearance, and a connection between Owens, Taylor and Smith was never established.

Meanwhile, police traced the page Zebb received on January 2 and determined it was placed at the home of his aunt, Ina Ustich. She denied making the call and reported someone had broken into her home while she was having dinner at Tamra Taylor's house. Tamra is Misty Taylor's mother, and Misty and Wesley were both present at the dinner. When Zebb's car surfaced, investigators found witnesses who claimed to have seen a woman driving it. The composite sketch resembled Misty Taylor.

Eighteen years later, there are still more questions than answers in the case. But without the discovery of the Codds' murders, there might never have been an indictment against Robert Jason Owens for the murder of Zebb Quinn.

"I've always known in my soul that it was him," said Brandi Quinn in reference to Owens. "Until the Codds' murders, I had a glimmer of hope that he was somewhat of a normal human being who would tell us eventually, but he's not a normal human being. There's always potential for other people. I don't understand how he could have done this by himself, and I don't believe he did the Codds by himself."

At this writing, it's not known when Owens will go to trial for Zebb's murder, but Brandi doesn't believe she'll ever know exactly what happened.

*A long time ago I had to get to be okay with not knowing the truth. I used to think I wanted to know the truth, but the moment this case came up with the Codds and we went to the news conference to hear those gruesome things was the most horrific thing ever. Because what happened to them is what you think may be somewhat true of what happened to my brother. It upset me so much because I had no concept of that type of evilness. I don't think he will ever come clean and say what happened.*

## 4

# HALLOWEEN HORROR

*I think I need a lawyer present.*
*—Richard Allen Jackson*

Thad and Katheryn Styles of Candler spent Halloween night 1994 walking the floor with worry, calling friends, and turning to their Bible for guidance. They were praying for the safe return of their only child, Karen. The recent Western Carolina University graduate had failed to show up for work after going for a run on the Hard Times Trail in Bent Creek near Lake Powhatan, and she also hadn't made it home. They were especially worried because the night's temperature was dipping into the thirties, and the twenty-two-year-old left wearing shorts and a T-shirt.

Karen went to the trail around 8:00 a.m. and parked her 1987 Plymouth Reliant near the trailhead, her wallet and keys tucked safely inside, while she carried a spare key with her. She was scheduled to work later in the day at the Asheville Mall, where she had a part-time job at Maurice's clothing store. It was simply a temporary job as she waited to start a new career. She had accepted a full-time position at a camp in South Carolina. It had been an all-boy facility but had opened it up to girls, and Karen was hired to help develop the girls' program, utilizing her recent bachelor's degree in therapeutic recreation. Tragically, Karen never had a chance to embark on her dreams.

Somewhere along the trail, Karen crossed paths with Richard Jackson, the adopted son of former Buncombe County commissioner, civic leader and

prominent real estate broker J.D. Jackson. He was armed with supplies he bought on October 28, 1994, at the Kmart on Brevard Road: a .22-caliber rifle and ammo, a flashlight and duct tape. He also had a stun gun, which he used repeatedly to paralyze Karen into submission. Jackson worked as a dishwasher at Mountain View Restaurant, owned by his father, which is near where Karen went to run. He had been frequenting the trail area looking for an opportunity for his crime.

Around 3:00 p.m. on Halloween, Jackson went back to the Kmart with his wife, Donna, and their two children. He got a refund for the rifle he had purchased days earlier and used the money to buy Halloween outfits and shoes for his kids. The next day, Karen's parents filed an official missing person report with the Buncombe County Sheriff's Department. Despite an intensive search, the authorities couldn't locate her. On November 13, a bloody T-shirt surfaced about two miles from Lake Powhatan, but still no sign of Karen.

A deer hunter made the shocking discovery of Karen's body the day after Thanksgiving. She was stripped from the waist down and bound to a pine tree with duct tape. She had been gagged, raped, terrorized and shot in the head.

As investigators tried to find the person responsible for her murder, they combed over any clues left behind. They found a spent rifle cartridge and a pornographic magazine at the scene but keyed in on a small clue that the uneducated observer might overlook. The police recovered a bar code from the duct tape wrapper in the woods near where Karen's body was found. That tiny piece of information led them to the Kmart on Brevard Road. They went through reams of receipts from the time of Styles's disappearance and pinpointed one that contained a purchase of a .22-caliber rifle, ammunition, a flashlight and duct tape. Because a signature was required on a federal form to purchase the rifle, investigators had a name: Richard Allen Jackson. Under direction of newly sworn-in Sheriff Bobby Medford, officers arrested Jackson at his workplace on December 20 and charged him with first-degree kidnapping, first-degree rape and first-degree murder. He was held without bond. Jackson confessed during interrogation.

It took a year before the case went to trial. The court first ordered a competency hearing for Jackson. He has a developmental delay and a history of questionable sexual behavior but was deemed competent to stand trial. Judge James Downs also allowed prosecutors to play Jackson's tearful confession for jurors to hear.

As testimony began, prosecutors introduced a sobering piece of evidence: a five-foot section of the pine tree that Styles was bound to. Among details in expert testimony: ten dark marks were identified on Karen's body, signs that she was shocked by a seventy-five-thousand-volt stun gun while she was still alive. Powder burns indicate the gun was placed next to her head when it was fired.

An FBI agent testified that bullet fragments taken from Karen's brain were too damaged to be matched to the .22-caliber rifle Jackson bought at Kmart, and a test bullet fired from the gun didn't match the .22-caliber cartridge found at the scene. This inconclusive ballistics evidence would come into play years later.

The prosecution rested after presenting eighteen witnesses and 170 pieces of evidence. Defense attorneys pushed jurors to find Jackson not guilty by reason of insanity, but they returned a guilty verdict on November 20, 1995. Judge Downs sentenced Jackson to death two days later.

But that's not the end of the story. Much to the Styleses' disbelief and devastating heartache, they received a call in April 1998 telling them that the North Carolina Supreme Court was ordering a new trial because Jackson's confession was allowed to continue even when he said he wanted an attorney present.

Jackson had been talking with officers for three hours, giving details of his crime, when Sheriff Bobby Medford walked into the room and asked him, "What did you do with the rifle that Karen Styles was shot with?"

At that point, the twenty-six-year-old Jackson said, "I think I need a lawyer present."

Investigators reportedly checked with the Buncombe County District Attorney's Office and allowed the confession to continue, and it's that decision that led the supreme court to overturn his conviction. In writing for the higher court, Justice John Webb said, "If at any time during an interrogation of a person in custody the person invokes his right to counsel, the interrogation must cease and it cannot be resumed without an attorney being present unless the defendant initiates a further discussion with the officers."

As district attorney Ron Moore prepared for a retrial, he reportedly became very concerned about the inconclusive ballistics evidence and tying the gun to the murder.

This time, Jackson escaped the death penalty by agreeing to a plea deal. He was sentenced in March 2000 to twenty-five to thirty years in prison after pleading guilty to second-degree murder, first-degree rape and

second-degree kidnapping. He was credited with the five years he served on death row.

But that's not where the story ends either. According to court documents, on November 6, 2000, a federal grand jury returned a superseding bill of indictment charging Jackson with one count of using a firearm on federal land during and in relation to a crime of violence, specifically murder, kidnapping and aggravated sexual abuse. His confession was allowed as evidence, and the jury found him guilty. During the sentencing phase, the twelve jurors unanimously agreed that the death sentence was warranted in this heinous case. On May 14, 2001, the district court found Jackson guilty and imposed the sentence of death.

A lengthy appeal process followed, but his death sentence was upheld.

# THE BABYFACE KILLER

*I think Lesley Warren is one of the most dangerous people that has come through
our court. He kills people with his bare hands, innocent women who have done
nothing to provoke him.*
—*former Buncombe County district attorney Ron Moore*

He's known as "The Babyface Killer" for his once-boyish looks, but there's nothing sweet and innocent about Lesley Eugene Warren. As a teen, he created a lot of havoc by vandalizing school buses, breaking into homes and writing threatening notes to a female schoolmate. According to court testimony, he also was a prolific user of cocaine, marijuana and alcohol, as well as the victim of abuse at home.

In 1983, when he was sixteen years old, he dropped out of Enka High School and spent some time as an inmate at the Juvenile Evaluation Center (JEC) in Swannanoa, North Carolina. That's where he had a fateful meeting with counselor Jayme Denise Hurley. She tried to help him move forward in a positive direction and even opened her home to him when he came seeking help after she had left her job at the JEC. He showed up at her door on May 24, 1990, and she agreed to let him sleep on her couch. Family members reported the thirty-nine-year-old Hurley missing the next day.

On July 18, her nude, decomposing body was found in a snake-infested area of national forest land off NC 151 in Candler. Officers reportedly killed at least six venomous snakes during retrieval of the body. A gold necklace hung around her neck. An autopsy later revealed she had been strangled to death.

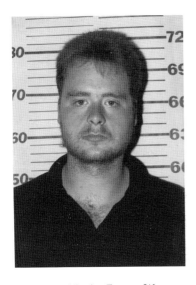

Mug shot of Lesley Eugene Warren. *Courtesy of High Point North Carolina Police Department.*

Warren ultimately confessed to four killings, but investigators believe Warren may be responsible for more. Ted Lambert with the Asheville Police Department testified in court that Warren confessed to killing "many more" than four people, but some of the unsolved crimes he claimed have never been proven. The spree of four confirmed killings began in 1987 when he took the life of Patsy Diane Vineyard in Sackett's Harbor, New York, which is located near the Canadian border. He was serving in the U.S. Army at that time and met Patsy in a bar. Her husband, a Fort Drum solder, was out of town. Warren was also stationed at Fort Drum. In June 1988, he was dishonorably discharged from the army after going AWOL in February 1988 and again in April. He moved to South Carolina with his wife, Tracey, and child, but they split in the early fall, and he moved back to Candler, North Carolina, and went through a training program at Alliance Truck Driving Center. After an on-again, off-again relationship with his wife, he found out she was pregnant with their second child in the summer of 1989.

In August 1989, he happened upon forty-two-year-old Velma Faye Gray after she wrecked her red 1985 Mazda RX-7 in Travelers Rest, South Carolina. He was working as a truck driver and stopped under the guise of helping her. He then beat her, choked her to death and dumped her body in Lake Bowen. Gray, who worked as a typesetter for Furman University, had been driving home from a singing gig—she sang lead for the band Reflections of Greenville. The band wrapped up and left the Elks Club on Haywood Street in Asheville around 1:15 a.m. on Sunday, August 27. Two fisherman discovered her remains in the lake around 7:10 a.m. Investigators say her hands were tied behind her back with shoelaces. She had bruises on her face, back, shoulders, upper arms, hands, wrists and feet. A pathologist said an injury to her neck was consistent with strangulation or a small concentrated blow.

Her car, missing its license plate, was discovered three days later in a field in north Greenville County. According to news reports, investigators believed she was abducted after running off the road about four miles from

her home in Travelers Rest. Witnesses told police they saw a truck driver stop to assist Gray.

Warren killed Jayme Hurley in May 1990 and then headed to Greensboro that summer, where he killed twenty-one-year-old Katherine Noelle Johnson on July 15, 1990, and left her nude body in the trunk of her car. He had met her hours earlier when a mutual friend introduced them at a company picnic. During interrogation, Warren told officers he left her car parked on the second floor of a garage at the Radisson hotel in High Point. Officials found her wearing only two gold bracelets on her right wrist and her bra twisted around her neck. The locations of the murders coincided with where Warren was living at the time. His victims were all attractive white women between the ages of twenty and forty-five.

He was first convicted of Gray's death and handed a life sentence in South Carolina for her murder before facing a judge and jury in Buncombe County. He was sentenced to death for Hurley's murder and remains on Death Row in Central Prison in Raleigh. His appeal was denied on July 10, 2018.

# ASHEVILLE COLD CASES

Sometimes those responsible for wicked acts manage to remain hidden. There are several murders of young women in the Asheville area that continue to baffle and haunt investigators. Will these cases ever be solved? The Asheville Police Department declined my request for an interview to get updates about the current status of these cold cases. In an email, APD officials directed me to the brief information available on the departmental website and said, "At this time we are unable to provide any additional information on the deaths of Virginia Olson, Pamela Murray or Amber Lundgren, as these cases are still under investigation."

## *Virginia Olson*

The body of UNCA sophomore Virginia "Ginger" Olson was discovered on a hillside overlooking the Botanical Gardens on April 15, 1973. She had been

raped and stabbed to death with a pocket knife. Her parents had stopped in Asheville just two days earlier—Friday, April 13—to visit with their daughter on their way to Dudley, Mississippi, to spend time with Ginger's maternal grandparents. They were in Mississippi when they got the call that Ginger had been killed. Her roommate, Jane Nicholson, said Ginger left their Craig Dormitory room around 1:00 p.m. that Sunday. She chatted with friends near the dorm and then headed in the direction of the Botanical Gardens. Around 3:30 p.m., two teenage boys found Ginger's body. The killer had ripped her T-shirt apart and used it to bind her ankles and gag her. Ginger was a drama major at UNCA and an active member of Theatre UNCA.

One of Ginger's friends, Ronda Stewart Hawk, has never forgotten the horrors of that day. "Ginger and I were working together on set design, building sets and providing props for an upcoming UNCA production," said Hawk. "We were redoing a wicker love seat. We had the rattan weave soaking and just needed to stretch it and attach it to the frame."

The Grass Roots, known for such songs as "Let's Live for Today" and "Sooner or Later," played a concert that afternoon on UNCA's quad. With all the activity and noise, Ronda said they decided to come back after the concert was over and finish their work. Ronda went to her parents' house for lunch and to study, while Ginger retreated to the Botanical Gardens. "When the noise got so loud and numerous people began wandering through the Botanical Gardens, she went across the street to land now used by the Forest Service," said Hawk.

Upon returning to campus, Hawk and another friend, Pat Henry, witnessed emergency vehicles on Weaver Boulevard:

> We saw a covered stretcher being brought out of the woods. I never imagined it was Ginger. Pat and I went to the dorm to get Ginger, only to find a note that she had gone to the Botanical Gardens to study and would meet us at Lipinsky. We went on to the theater and started working. She never showed. We checked back at the dorm and no one had seen her.

News of the brutal murder soon exploded across campus, and Hawk realized the stretcher the emergency crews carried out of the woods had held the body of her friend.

The case remains unsolved, but there has been speculation over the years that a patient at nearby Highland Hospital was responsible and quickly relocated to another state by his prominent family. An article dated March 2, 1985, in the *Asheville Citizen-Times* fueled that speculation:

*Police are sure they know who killed Virginia Marie Olson....Police questioned a man the day after the killing but no arrests were made. [Captain Will] Annarino said he knows who did it—and has known pretty much all along. "I know where he's living and where he works," Annarino said. "The man lives out of state and has mental problems, which is one reason why police have had such a hard time getting concrete evidence against him."*

## Pamela Murray

Love was on the mind of twenty-three-year-old Pamela Murray on the morning of Valentine's Day 1987. She spent time baking cookies with her grandmother as a sweet treat for her fiancé, John Huggins, of Pisgah Forest. She left her grandmother's house between 12:00 and 12:30 p.m. An hour later, passing motorists spotted her body on Azalea Road in East Asheville. She was found on her back lying in a pool of blood near a wooded area about a mile from Recreation Park. She had been shot to death—one bullet penetrated her head, and the other was fired at her back. The next morning, officers found her 1982 Oldsmobile Toronado at the Asheville Mall. A search of the interior revealed signs of a slight struggle; the freshly baked cookies were strewn throughout the car. Police believe she was abducted from the Asheville Mall and driven to Azalea Road, where she was killed. A witness reported seeing a man approach Murray in the parking lot near Sears and grab her arm. They left in Murray's car with the man driving. Police think the killer drove her car back to the Asheville Mall after the murder and left it. Despite a composite sketch of the suspect based on the memory of the witness, no arrests have ever been made.

## Amber Lundgren

Ten years after Pamela Murray's body was found on Azalea Road near Recreation Park, a man walking his dog discovered the body of Amber Lundgren in the same area. He found her on Saturday, June 6, 1997. An autopsy revealed she died from a single stab wound to the neck. The night before, she met up with some girlfriends at the Bar Code nightclub in Asheville, which was located across the street from the Masonic Temple. She left the club alone between 2:00 and 3:00 a.m. She was last seen walking

on Lexington Avenue and one witness remembered seeing her at 3:15 a.m. on Walnut Street between Carolina Lane and the entrance to Gatsby's. Police heard from other witnesses who said they saw a man near where her body was found between 3:00 and 4:00 a.m. They described him as a white man between the ages of twenty and forty-five with a stocky build and dark reddish-brown hair and beard. He was driving a dark-colored truck with toolboxes running the length of the bed. Authorities released composite drawings of the suspect and his truck, but no one has ever been arrested for Lundgren's murder. At the time of her death, she worked as an assistant manager at Pier One Imports and planned to enroll at UNCA or possibly join the Peace Corps.

When Amber Lundgren first disappeared, her mother, Debi, encouraged people to look closely at the composite sketches. "Amber's Story," published on May 10, 1998, in the *Asheville Citizen Times*, warned the public: "Debi wants people to realize that someone who kills women may be living undetected in our community. He may sit next to you in church or drive your daughter's school bus. He could be any age, any race. He could wear jeans or khakis, a uniform or Armani suits."

## *Kelly Lane Smith*

Employees at Highland Clays made a startling discovery on their lunch hour on July 31, 2006. They called police, alerting them of skeletal remains in the French Broad River behind 600 Riverside Drive. A week later, additional remains were discovered in the storm drain at the intersection of Roberts and West Haywood Streets. The remains were identified as those of thirty-five-year-old Kelly Lane Smith, a local prostitute, who was last seen in downtown Asheville on Saturday, July 29. Following her murder, Our Voice Asheville created Kelly's Line—an anonymous reporting line for the Asheville Sex Worker Outreach Project (ASWOP).

# II

## Sedition and Corruption

# AMERICA'S HITLER

*Silver symbolizes the purity of our fight and the purity of our race.*
*—William Dudley Pelley*

William Dudley Pelley stayed laser-focused on the happenings in Germany in the early 1930s. He rejoiced over Adolf Hitler's rise to power and cheered when Hitler was named chancellor on January 30, 1933. The next day, Pelley publicly announced a Fascist group he headquartered in Asheville called the Silver Legion of America, more often referred to as Silver Shirts, modeled after the Nazi Party's Brown Shirts. Support in Asheville was modest at best, but Pelley did have chapters of the Silver Shirts take form in twenty-two states. It's estimated membership hit its peak in 1935 with 15,000 followers, but Pelley claimed there were 100,000. Members dressed in a military-style uniforms with oversized red Ls sewn over their hearts. Pelley chose an **L** to represent **L**oyalty to America, **L**iberation from Materialism and the Silver **L**egion.

Three and a half years later, in September 1936, he announced his candidacy for president of the United States, choosing "For Christ and the Constitution" as his platform. His vision paralleled the Nazi Party, as it called for the registration and persecution of American Jews. He envisioned a "Christian Commonwealth" without paper money, banks or big cities. During one campaign speech, he took the stage and said, "I am for Adolf Hitler, and I claim to be the Adolf Hitler of America." He ultimately wound up in jail, convicted on eleven counts of criminal sedition and conspiracy in

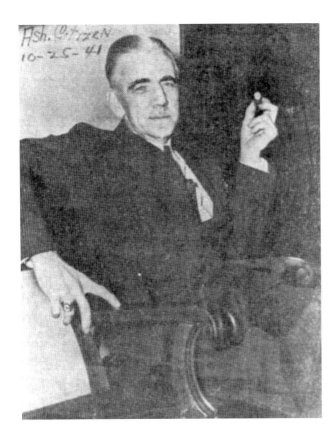

William Dudley Pelley was a prolific writer as well as the self-proclaimed "Hitler of America." *North Carolina Collection, Pack Memorial Library, Asheville, North Carolina.*

a federal trial in 1942. At that time, he was under a suspended sentence from a 1935 trial in Buncombe County for violating the state's security law.

So how did Asheville become tied to this type of mindset and activity?

I sat down with Jon Elliston to discuss Pelley and his life in Asheville. Elliston is a prolific Asheville writer who has heavily researched and written about Pelley. He currently serves as senior editor of *WNC Magazine* and penned a piece on Pelley in the January 2018 issue.

Pelley operated Galahad College on Charlotte Street for about eighteen months, and he also had a printing business, Galahad Press, in Biltmore Village. Galahad Press went into bankruptcy in 1934, and Pelley established Skyland Press in Biltmore in 1939. "He was all about the pamphlet, the flyer, the circular and the little book—he cranked it out all the time," said Elliston.

*That's the biggest part of why he was a threat. He was a good propagandist. For good or for bad, he was also kind of a nut. He was into all this spiritualism and dealing with the dead and talking to them. He wound up*

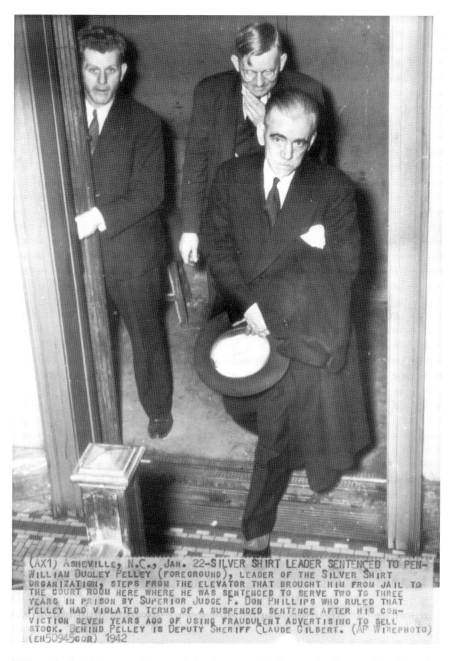

(AX1) ASHEVILLE, N.C., JAN. 22—SILVER SHIRT LEADER SENTENCED TO PEN—
WILLIAM DUDLEY PELLEY (FOREGROUND), LEADER OF THE SILVER SHIRT
ORGANIZATION, STEPS FROM THE ELEVATOR THAT BROUGHT HIM FROM JAIL TO
THE COURT ROOM HERE WHERE HE WAS SENTENCED TO SERVE TWO TO THREE
YEARS IN PRISON BY SUPERIOR JUDGE F. DON PHILLIPS WHO RULED THAT
PELLEY HAD VIOLATED TERMS OF A SUSPENDED SENTENCE AFTER HIS CON-
VICTION SEVEN YEARS AGO OF USING FRAUDULENT ADVERTISING TO SELL
STOCK. BEHIND PELLEY IS DEPUTY SHERIFF CLAUDE GILBERT. (AP WIREPHOTO)
(EH50945COR) 1942

William Dudley Pelley stepping out of the elevator at the Buncombe County Courthouse in
Asheville. *North Carolina Collection, Pack Memorial Library, Asheville, North Carolina.*

*getting into UFOS and out of body experiences and people tell me that's what the Nazi leadership did as well. He definitely latched onto that weird current of militarism, Fascism and an odd spirituality that was loosely tied to religion, but he didn't seem that religious to me. I don't remember what brought him here. He was coming out of Hollywood and New York. He had a real career as a screenwriter. He was an odd dude.*

Here's a brief look at some of Pelley's life highlights:

- Born on April 12, 1890, in Lynn, Massachusetts.
- High school dropout.
- Son of a Methodist minister who later became a manufacturer of tissue paper products.
- Prolific writer/publisher of newspaper and magazine articles, novels and screenplays.
- Spiritualist who said he survived a near-death experience.
- Founder of the short-lived Galahad College.
- Hater of Jews.
- Asheville resident for more than a decade, moving here in 1932.
- Convicted and jailed for sedition in World War II.

In 1939, he penned "The 45 Questions Most Frequently Asked about the Jews with the Answers," which included such statements as this:

*We have something like 12 million unemployed already, and only about so much work to go around. If ungodly numbers of refugee Jews come over here, somebody must support them. If they apply for work and support themselves, it means that an equal number of native American Gentiles must relinquish their present jobs and either go on Relief or join the bread line.*

Pelley's words evoke the phrase "those who don't learn from history are destined to repeat it," as the views of some in the United States today seem hauntingly similar.

## PELLEY'S LIFE AS A WRITER

William Dudley Pelley created the Silver Legion of America, also known as the Silver Shirts. *North Carolina Collection, Pack Memorial Library, Asheville, North Carolina.*

Pelley had a flair for stringing words together and penned everything from news articles to short stories and screenplays for movies. At the age of nineteen, he began publishing the *Philosopher* and then spent some time editing and publishing a stream of newspapers in Massachusetts and Vermont. At one point, he served as a crime reporter for the *Boston Globe*. From there, he went overseas, serving as a war correspondent for the *Saturday Evening Post*. In that role, he covered the Russian Civil War. When he returned to the United States, he landed in California and devoted his time to writing novels, short stories and screenplays and publishing magazines. He also established *Hi-Hat Magazine* in Hollywood and Pelley Press, a publishing and printing house in New York, in addition to serving as president of Pelley and Eckels, an ad agency in Los Angeles. He won O. Henry Awards for two of his short stories: "The Face in the Window" in 1920 and "The Continental Angle" in 1930. Pelley earned a good living as a writer, but it was his article "Seven Minutes in Eternity" in the *American Magazine* that brought him national fame. In it, he detailed his out-of-body experience. He said he was fully awake—aware that he was dying—and claimed to have a conversation with someone on the other side:

> *Quizzically he asked me: "Don't you remember being here before?"*
>
> *"When have I ever been here before?" I asked him.*
>
> *"Countless times," he assured me, smiling more indulgently. "You left this plane or condition to go down into earth-life and function as the person you know yourself to be. Don't you remember that?"*
>
> *"You mean I lived as a person before being born as William Dudley Pelley?"*
>
> *"Everyone has lived before—hundreds of times before. People still in earth-life will live hundreds of times again—as they may have need of the mortal experiences. It's the very basis for all human relationships."*

After the article came out in print, Pelley claimed he had a "mental radio that could tune in on the minds or voices of those in another dimension of being." He founded a new publication called the *New Liberator* to promote and advance his theories of spiritualism. The first issue came out in May 1930. He then moved to Asheville in 1932 and changed the magazine's name to *Liberation* at the same time he was founding the Silver Shirts of America.

# GALAHAD COLLEGE

After arriving in Asheville, Pelley quickly established Galahad College in a prominent building on Charlotte Street and Sunset Parkway that once served as the Asheville Clubhouse for Women. Classes began on October 17, 1932, with the fall term running until December 16. The title of the course catalogue was "Make Statesmanship Your Profession!" Here's a sample of the information contained in the catalogue:

> *America is now suffering from a great national cancer: government by hoodlums and scoundrels, because there are no trained executives and administrators to make a life-long profession of carrying out the will of its decent citizenry. The average business man and woman is too pre-occupied with commercial or domestic responsibilities to volunteer extravagant amounts of time and effort toward running the country efficiently in the capacity of public servant himself or herself. We must take our nation out of the hands of predatory cliques and shysters by furnishing the decent citizenry with an enlightened and trained class of candidates for civic positions, candidates who have declared themselves as public administrators by a profession to which they mean to devote their lives. We have no such class in America today.*

The faculty at the college taught such subjects as spiritual eugenics, cosmic mathematics, ethical history and social metaphysics. In a published report, school officials said that "the knowledge offered at Galahad is uncensored knowledge. Orthodox notions of social, political and spiritual fundamentals are completely abolished." Galahad College was short-lived in Asheville. It lasted about eighteen months.

## TRIED AND CONVICTED

Pelley's words gained him fame. They also brought him pain and time behind bars. His harshly critical words and writings about President Franklin D. Roosevelt and the nation's involvement in World War II resulted in his arrest on a sedition charge. He was accused of using his publication the *Galilean* to create a bad feeling between the United States and its allies. He ridiculed the war production and military programs and denounced American diplomacy. Prosecutors said his articles were "surprisingly consistent with Axis propaganda."

William Dudley Pelley in court. *North Carolina Collection, Pack Memorial Library, Asheville, North Carolina.*

William Dudley Pelley spent time in jail for sedition during World War II. *North Carolina Collection, Pack Memorial Library, Asheville, North Carolina.*

Here are a few excerpts:

> *To rationalize that the United States got into the war because of an unprovoked attack on Pearl Harbor is fiddle faddle. Unprovoked, indeed! All Americans are not fools...*

> *It is a fact that nobody in the whole United States had a flicker of feeling, one way or another, against Japan or Hitler except racial blocs or refugees evicted from their financial sinecures abroad...*

> *There is not the slightest enthusiasm anywhere in all America for this war, with the sole exception of the Jewish ghetto sections of our swollen cities. And those ghettos will not fight. Gentile boys from factory and farm must do the fighting...*

In his closing statement, U.S. District Attorney Howard Caughran addressed Pelley, calling him "a traitor to your country—you'll go down in history with Benedict Arnold and Aaron Burr." He continued: "The Silver Shirt League was a bristling military organization, a rising private Army.

He mustered it because, as he says, President Roosevelt and Congress weren't doing anything about the Community menace. So he decided to take matters into his hands."

The fifty-two-year-old Pelley was convicted in August 1942 and sentenced to fifteen years in a federal penitentiary in Terre Haute, Indiana. He was paroled in 1950 after serving eight years.

## SOULCRAFT

After getting out of prison, Pelley stayed in Indiana and turned his attention to a philosophy he called Soulcraft. He described it in a pamphlet as "an enlightening philosophy of life based on the soundest and most provable fundamentals of sacred psychical research and extra sensory perception." In the years following prison, he proved to be just as prolific in publishing his works as he was before his conviction. But this time, he steered away from political writing. He produced a monthly magazine called *Valor*, which he filled with the tenets and principles of American Soulcraft. He also distributed tape recordings to more than one hundred Soulcraft groups across the country and published more than thirty Soulcraft books, such as *Why I Believe the Dead Are Alive* and *The Man Who Created Satan*. In 1954, he raked in around $250,000 and was reportedly soaring to a $500,000 in revenue in 1955. He died in 1965 at the age of seventy-five, leaving behind his wife, Agnes, a son and daughter and a bizarre, twisted legacy as a Fascist, spiritualist and propagandist.

# BANK FRAUD

*What would you have done? Would you have closed the bank and lost it, or would you have made an honest effort to save it?*
*—former Asheville mayor Gallatin Roberts*

The headline of the February 22, 1931 edition of the *Asheville Citizen-Times* screamed the news: "18 BANKERS AND MUNICIPAL OFFICIALS INDICTED BY GRAND JURY TO FACE TRIAL AT SPECIAL TERM." Those facing the heat included respected men whom city residents would have never believed would be on the wrong side of the law. They included Gallatin Roberts, former Asheville mayor; L.B. Rogers, former city commissioner of public works; C.H. Bartlett, former city commissioner of public safety; Newton M. Anderson, former chairman of the Buncombe County Commission; James W. Grimes, former county commissioner of public institutions; L.L. Jenkins, former county treasurer and American Bank president; Wallace B. Davis, founder and president of the Central Bank and Trust Company; Russell C. Davis, active vice-president of Central Bank and Trust; and W.A. M'Geachy, former president of the Biltmore-Oteen Bank, among others.

The first count in the bill of indictment charged conspiracy between city commissioners and bankers "to misappropriate and prevent, moneys, funds and credits of the city of Asheville in a sum amounting to more than $4,000,000." It goes on to say that Gallatin Roberts, L.B. Rogers, H.C. Bartlett, Wallace B. Davis and Russell C. Davis

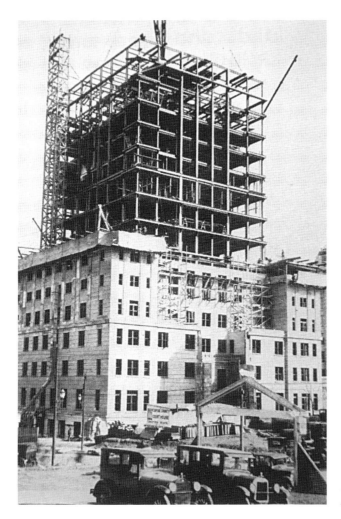

Construction of the Buncombe County Courthouse during the building boom of the 1920s. It was built between 1924 and 1928. *North Carolina Collection, Pack Memorial Library, Asheville, North Carolina.*

*being persons of fraudulent minds and evil dispositions, unlawfully, willfully, fraudulently, feloniously and deceitfully did combine, conspire, confederate and agree together by diverse false pretenses to cheat and defraud the city of Asheville and to misapply, misappropriate and pervert the moneys, fund and credits of said city in a large amount, to wit, a sum in excess of $4,000,000 by false representing and pretending that the revenue, moneys and funds of said city were exhausted, and that it was necessary, in order to pay the current expense of operating the government of said city to sell large issues of revenue anticipation promisory [sic] notes of the said city of Asheville.*

Now all that sounds like a bunch of mumbo jumbo, but peeling back the layers, Asheville and Buncombe County were deep in debt from the building boom of the 1920s. When the Great Depression and devaluation began in 1929, the situation became worse and then plunged into desperation, leading to the closing of area banks. Asheville and Buncombe County officials had continued to borrow money despite a huge mound of debt and despite the fact that both had large sums of unsecured deposits in Central Bank and Trust. The *Statesville Record and Landmark* reported on the crisis in December 1930: "So it appears that while there were millions of dollars of public funds on hand the local governments couldn't get their own funds. Withdrawal might close the bank." It went on to say the local politicians were giving Central Bank and Trust their business as a quid pro quo relationship to help the bank. The *Statesville* article continued: "It amounts in effect to financing the favorite bank with public funds....Whatever the idea of the governing authorities in Asheville and Buncombe they did continue to put more money in the favorite bank that couldn't give them what they had." Between September 1 and November 20, 1930, the City of Asheville deposited $6,143,911.68 into Central Bank and Trust. The city continued to make deposits knowing it couldn't draw out what it had. The result was dire. Asheville faced enormous debt and high taxes along with the general depression and a broken bank that held millions of public funds.

The whole situation started falling like dominoes on November 20, 1930—that's the day known as "Black Thursday"—when eight Western North Carolina (WNC) banks closed their doors. The first to shut down was Central Bank and Trust, the largest bank in Asheville. The city lost $4 million of public money when the bank shut down. Buncombe County had just over $3 million deposited. The bank was located in the Legal Building on Pack Square. French Broad Chocolates is now in that location. Customers found a note on the door saying it was closed "by order of the board of directors for liquidation and conservation of assets for protection of the depositors." Within hours, seven other banks in the region were forced to close, including the Biltmore-Oteen Bank and two in Hendersonville: the First Bank & Trust Company and American Bank & Trust Company. State banking officials attributed the closures to the collapse of the real estate boom of the 1920s.

When word started spreading among Asheville citizens that Central Bank and Trust failed to open, frightened, frantic people stormed the American National Bank and demanded their money. Bank president L.L. Jenkins appealed to the crowd to remain calm. He said, "We have ample funds either

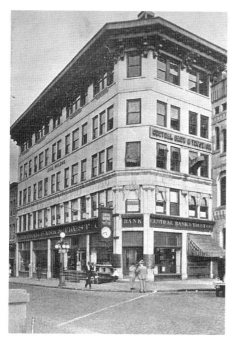 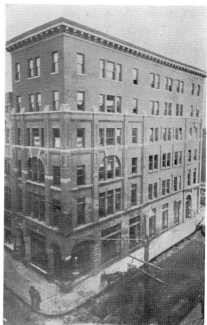

*Left*: Central Bank and Trust, Asheville. *North Carolina Collection, Pack Memorial Library, Asheville, North Carolina.*

*Right*: Asheville National Bank. *North Carolina Collection, Pack Memorial Library, Asheville, North Carolina.*

here or in transit to meet all your demands. All your demands will be met if you will only give tellers and me an opportunity to work. The bank has ample resources. Just go out and come back in businesslike fashion. There is no necessity for worry." The *Asheville Citizen-Times* reported, "There was something so heroic, so convincing in the very act that some of those who had joined the stampede broke into cheering and others echoed his appeal for confidence."

The next day, American National Bank closed, as did the Citizens Bank of Bryson City. This brought the number to ten banks in WNC that had ceased operations since November 20, 1930. The financial devastation wiped out some people's life savings, and homes and small businesses were auctioned off, even those businesses that had been in the same family for generations.

# Gallatin Roberts

Gallatin Roberts was a highly respected member of Asheville's leadership community, active in the Democratic Party, an elder of his church and a Sunday school teacher. He earned a law degree at Wake Forest University, established a legal practice in Asheville and then served as Buncombe County attorney in 1911 and 1912. He also was a state representative in 1911, 1913, 1915 and 1917 and then served two terms as Asheville mayor, from 1919 to 1923 and 1927 to December 1930, when he resigned amid the clamor that resulted from the failed banks. When Central Bank and Trust failed, Roberts said he would stay in office but finally bowed to public pressure. Asheville taxpayers demanded his resignation when it became public knowledge that auditors had warned him and two county commissioners about the financial dangers looming in their dealings with Central Bank and Trust. Roberts had been widely respected by his friends, family and associates, but that respect came tumbling down with the bank failures.

Before his indictment along with seventeen other Asheville leaders and bankers, Gallatin Roberts wrote a letter to his son, saying, "You need not be surprised if the grand jury should indict the City Commissioners, the County Commissioners, all the bank officials and bank directors, but it will not amount to anything."

Gallatin Roberts proclaimed his innocence, but on February 25, 1931, just three days after news of the indictment exploded across the front page of the newspaper, he went into the bathroom on the fourth floor of the Legal Building at Pack Square and shot himself in the head. He had recently reopened his law office on the third floor. He left three suicide notes—one to his family, another to his friend George Pennell and the third to the people of Asheville. They were handwritten on the backs of blanks for city delinquent tax collections. In his note to the town, he said:

*To the People of Asheville:*

*My soul is sensitive, and it has been wounded unto death. I know exactly who the men are who were instrumental in trying to destroy me, but now, I forgive them. For twenty years, I was in public life, and I never did a dishonest act during all these years and yet, I have been shamefully charged with committing a felony. God knows I did no wrong during my term in office. My hands are clean and my conscience is clear, and I want to say*

Asheville mayor Gallatin Roberts killed himself after Asheville banks collapsed in November 1930. *North Carolina Collection, Pack Memorial Library, Asheville, North Carolina.*

*further that Mr. Bartlett and Mr. Rogers are both clean good men, and have done no wrong.*

*I have given my life for my city, but I am content. I did what I thought was right. I trust the people of Asheville will cease to wrangle, and all pull together for the common good. Why do you hate each other? Don't you know that life is just like a fleeting shadow, and that you will soon pass to the great beyond? I do not hate a soul on this earth. Won't you people highly resolve to cease your bickering and strife? I want you to do this.*

*I worked hard for a larger and better City. I knew that it was imperative. Every act of my life during my term of office was for that which I thought was for the best interest of this community.*

*When I went into office nearly four years ago I found millions of dollars of the people's money in the Central Bank, and I tried with all my soul to protect it, and did protect it for nearly four years.*

*What would you have done? Would you have closed the bank and lost it, or would you have made an honest effort to save it?*

*Farewell and adieu,*

*GALLATIN ROBERTS* [signed]

Roberts's suicide was the second related to Asheville's banking difficulties. The first took place on February 17, when Arthur E. Rankin, a former president of the American National Bank and former vice president of the Haywood Street branch of Central Bank and Trust Company, shot and killed himself at his home on West Avon Parkway in Lakeview Park. Officers found him lying about one hundred feet from the kitchen door clutching an obsolete .38-caliber Iver Johnson revolver. A published report of his death said, "He was considered one of the best informed men in this section on credits, and was constantly sought for advice by investment and banking houses." He was an Asheville native and son of James Eugene Rankin, who served as Asheville's mayor for several terms. Like Roberts, he was well respected in the Asheville community and was a member of the Biltmore Forest County Club, Trinity Episcopal Church and the Knights of Pythias. He left behind a wife, Nancy, and two children.

A cashier at the failed Central Bank, J. Charles Bradford, attempted suicide. He slashed his throat with a razor blade but survived.

# HEADED TO JAIL

Wallace B. Davis, the former president of the failed Central Bank and Trust Company, lived to see his day in court, and he wound up behind prison bars. In June 1931, a judge sentenced him to serve five to seven years for violating banking laws in connection with the bank failure. Then, in August 1931, he earned an additional four to six years in prison for his part in a conspiracy involving a former U.S. senator and his son. The trio was convicted of conspiring to violate the North Carolina banking laws following the collapse of Central Bank and Trust Company.

Colonel Luke Lea, a Tennessee newspaper publisher and former senator, was sentenced to serve from six to ten years in NC State Prison for defrauding Central Bank and Trust of $1,136,000. His son, Luke Lea Jr., was also convicted, but attorneys petitioned the court to let the younger Lea off with a $25,000 fine because he was twenty-three and simply doing as his father told him to do. Colonel Lea had a distinguished career—he commanded the First Tennessee Field Artillery as a lieutenant colonel until October 18, 1917, when he rose to the rank of colonel. He was honorably discharged on April 19, 1919, and received the Distinguished Service Medal. He went

Colonel Luke Lea. *North Carolina Collection, Pack Memorial Library, Asheville, North Carolina.*

home to Tennessee to regain control of his newspaper interests and then won election to the U.S. Senate at the age of thirty-one.

On April 22, 1935, North Carolina governor John Christoph Blucher Ehringhaus paroled Davis, who had been serving his sentence since October 27, 1932. His wife and son picked him up in Raleigh and returned to their home, located at 81 North Liberty Street.

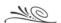

## CURRENT CORRUPTION

While I was writing this book, local media outlets exploded with reports of corruption in Buncombe County government. With book production deadlines closing in, there's only time to skim the surface of a story

that gets deeper by the day, but it deserves a mention in a book about Asheville wickedness.

Federal prosecutors slapped former Buncombe County manager Wanda Greene and her son, Michael Greene, with indictments detailing wire fraud, federal program fraud/embezzlement, conspiracy and money laundering. The most serious charges carry a maximum twenty-year prison sentence per count along with a fine of $250,000. It took an hour for the twenty-two-page indictment to be read aloud in federal court in June 2018—at that time, the sixty-six-year-old Wanda Greene pleaded not guilty and asked for a jury trial.

She's accused of manipulating the purchase of whole life insurance policies for herself and select county employees, including her son. The indictment charges her with purchasing the policies using more than $2 million of county funds earmarked to pay for settlements related to the wrongful convictions in the Walter Bowman shooting death. Bowman was killed in September 2000 in his Fairview home. Five men pleaded guilty to charges related to the murder, but two of them—Robert Wilcoxson and Kenneth Kagonyera—were exonerated by the N.C. Innocence Inquiry Commission in 2011. Both men filed federal lawsuits against Buncombe County. Money set aside for the wrongful convictions is what federal prosecutors say Greene spent on the sly. She's accused of cashing out two of the life insurance policies for $396,000 after she retired in 2017.

The sordid scheme also allegedly involved using county credit cards for personal purchases. Federal investigators connected the dots on receipts to show Greene and her son purchased items with about $200,000 of county money. A sampling of items bought included gift cards at a variety of retailers, a $340 Dyson vacuum, $810 gym equipment, iTunes purchases, clothes, expensive meals and home décor.

Buncombe County filed suit against Greene in June 2018 in an attempt to recover hundreds of thousands of taxpayer dollars.

# CORRUPTION AND THE SAGA OF SHERIFF BOBBY MEDFORD

*To conclude that Mr. Medford and Mr. Penland aren't guilty of these offenses, one must drink from the decanter of insanity. They prostituted the office of sheriff.*
—*Assistant U.S. attorney Corey Ellis in closing arguments*

In the spring of 2008, I got a call from Asheville criminal defense attorney Stephen P. Lindsay. "I need your help," he said. He went on to explain that he was appointed to represent former Buncombe County sheriff Bobby Medford in his federal corruption trial; Medford was accused of taking kickbacks from illegal video gambling operations at quickie marts and mom-and-pop shops around the county, among other crimes. Lindsay and I knew each other from serving on the executive board of the PTO at Ira B. Jones Elementary School, where my kids, along with his, were students. "But I'm not a paralegal. I don't have legal experience. How can I possibly help with this?" I quizzed. "I need your interviewing, reporting and writing skills," he answered. He told me he thought I would enjoy the case and prophetically said, "You might even write about it someday."

That's how I found myself transcribing grand jury testimony in the federal prosecutor's offices in downtown Asheville, interviewing witnesses and writing up drafts of what they revealed and shuttling Medford to attorney appointments and to his lie detector test.

Medford stayed at his sister's house while awaiting trial; an electronic device around his ankle monitored his movements. On days when I had to transport him to other locations, I would have to make a call to notify the

prison system that I was picking him up, where I was taking him and how long we'd be gone.

Medford's sister lived in a small brick ranch-style house in the Alexander area, just off Leicester Highway. One day when I arrived, Medford was eased into a living room recliner watching a black-and-white John Wayne movie. "Water," a voice cried from the screen. "There must be water here somewhere." The man in the movie was digging in the desert, hoping to hit a stream to quench his thirst. How appropriate, I thought, that here was a former sheriff digging for relief from the dire situation in which he found himself. Medford seemed tired, dejected and resigned as he went through the trial process. He also suffered back pain, which made it difficult for him to rise from chairs or get in and out of my car without effort. Our conversations were sparse and simple as I carted him around town.

In October 2008, a jury handed down a guilty verdict against Medford on corruption and extortion charges. Federal court judge Tim Ellis sentenced him to fifteen years in prison followed by three years supervised probation. In his remarks to Medford, Ellis said, "You have betrayed the trust conferred on you.…You abused that power in order to enrich yourself."

Today, Medford sits in the Federal Correctional Complex, Butner Low, in Butner, North Carolina. This prison has seen its share of high-profile inmates, including John Hinckley Jr., who tried to assassinate President Ronald Reagan; fallen televangelist Jim Bakker; and Bernie Madoff, the New York financier who found himself behind bars after his elaborate Ponzi scheme began unraveling in 2008.

# MEDFORD'S DOWNFALL

Medford began working for the Buncombe County Sheriff's Department at the age of twenty. He knew the county well as a Woodfin native and graduate of Erwin High School. He left the department in 1970 when Tom Morrissey replaced Harry Clay as sheriff. Medford then joined the Asheville Police Department as a detective and stayed there for thirteen years. Before he was elected Buncombe County sheriff in 1994, running as a Republican, Medford served as the police chief in Rutledge, Georgia, and even had a stint as a car salesman for Black Mountain Chevrolet. He was twice elected Buncombe County sheriff and served from 1994 to 2006. He lost the 2006 election to Van Duncan.

At the time of his arrest on December 13, 2007, Medford lived in a modest one-bedroom apartment in Weaverville with longtime girlfriend Judi Bell and Miss Meredith, his beloved pet bird, described in a *Mountain Xpress* article as "a one-eyed green parrot with red-and-black tipped wings." Officers knocked on the door at 7:30 a.m. that morning and told Bell they needed Medford to come outside. They claimed Medford's car had been vandalized and he needed to inspect the damage. Medford was still asleep. Clad in pajamas, robe and sandals, Bell agreed to go with them to look at the car. As she approached the vehicle, federal agents told her they were there to arrest Bobby. Officers stormed the apartment and brought a startled Medford out in handcuffs.

So how did a man elected to uphold the law find himself sitting in a prison cell? The federal case revolved around illegal payouts for video poker and a sheriff who took bribes from the operators to look the other way. As reported by the *Asheville Citizen-Times*: "North Carolina barred cash payouts from video poker machines and made them illegal altogether in July 2007. But businesses across the region kept the machines in back rooms that were turned into small underground casinos. A single machine could pull down $30,000 a year, by one federal law enforcement estimate."

In opening statements of the trial, Assistant U.S. Attorney Richard Lee Edwards provided a quick snapshot of Medford's alleged crimes. "Mr. Medford used his position to extort money from people, both his associates and others in the video poker industry. It was a pay-to-play system. People were paying money to the sheriff and his deputies because of the position he held here."

Edwards used a flow chart in court to show how the scheme worked. Video poker machine owners had to register the machines with the sheriff's office. He noted that Medford's department reported 365 operating machines in Buncombe County, yet the department ordered 1,385 stickers. Stickers were required to mark legal machines. Apparently, owners were being extorted for the stickers and paid fees directly to the sheriff or his associates. They also were under pressure to pay entry fees in the semiannual Bobby Medford Golf Classic. The prosecution said after the year 2000, about three-quarters of the golf tournament donors were video poker owners.

Medford wasn't the only sheriff's department employee in the government's grasp. The federal indictment also included reserve captain Guy Penland, former lieutenant Ronnie Eugene "Butch" Davis and former lieutenant John Harrison. They were charged with conspiracy to commit extortion, conspiracy to commit money laundering, five counts

Former Buncombe County sheriff Bobby Lee Medford (*center*). *From the* Asheville Citizen-Times.

of mail fraud and obstruction of state and local law enforcement charges, including making false statements. The mail fraud is connected to providing registration stickers for illegal machines.

Officials also clamped down on business owners like Demetre Theodossis, who operated dozens of video poker machines at his four Hot Dog King locations. During a raid at his home, agents found $1.8 million in cash in a variety of hiding places: PVC pipes, dog food containers, his attic and false walls. It was revealed in court that Theodossis gave Medford $1,000 every month to turn a blind eye to the illegal gambling machines in his restaurants. James "Jim" Lindsey, owner of Mountain Music & Amusement, and Jackie Shepherd, owner of Western Amusements, were among other witnesses who took turns testifying about bribes they had paid Medford.

Jerry Pennington, who served as the former marketing manager for Henderson Amusement, provided damning testimony about illegal payments made to Medford that let the company operate the video poker machines. He told the court he personally handed Medford envelopes filled with cash seven or eight times—the amount was generally in the $2,500 to $3,000 range, as well as $5,000 for Medford's reelection campaign. He also

told of $10,000 he presented to Captain Guy Penland for one hundred video poker machine registration stickers. Federal investigators laid out proof that Henderson Amusement had 350 machines in North Carolina, which raked in $5 million over seven years from video poker machines. The company made illegal cash payouts in fifteen WNC counties. Pennington testified that his company paid the sheriff $3,300 a month. In exchange for Pennington's testimony, Judge Ellis agreed to reduce his federal prison sentence from sixty-three to thirty months.

Another business owner, Imran Alam, who operated seventeen gas stations and convenience stores, had his sentence reduced from twenty-one months in prison to time served (three weeks) plus five months of community confinement. In all, twenty-five people pleaded guilty in the federal investigation into Western North Carolina illegal video gambling.

## Show Me the Money

Medford enjoyed going to Harrah's casino and pressing his luck. Federal authorities built a case to show that he used video poker bribes to fund his gambling addiction. Medford refuted that on the stand: "It was not an addiction. It was some place to go to get things off your mind. I got old and sick."

Investigators determined that Medford lost $54,142 in 2006 alone at Harrah's Casino. He also spent 162 workdays in 2006 gambling at Harrah's and drove there in a county car. The *Asheville Citizen-Times* said, "That means he only spent 99 days on the job, if weekends aren't included."

"We really should talk about the whole gambling aspect of it because the fiction that was perpetrated by the government about how much money was spent at Harrah's was sad, really sad because it illustrates a fundamental failure to understand how Harrah's accounting system works," said Medford's attorney Steve Lindsay. He elaborated:

> *I could go to Harrah's, for example, with $100 and in a nighttime on their books gamble $25,000 because it records how much is spent, but it doesn't record how much is received from them in winnings. If I win and then I put it back in the machine, it looks on the books as if I've spent $25,000 of my money at Harrah's when I haven't. I could walk back out with the $100 I went up there with and have gambled all night long. When*

*you add on top of that the fact that people who go to Harrah's regularly receive certain incentives. They'll comp you on your hotel. They'll comp you on transportation. They may give you $1,000 in gambling money so you're really playing on their money. So in the end, all these numbers the government trotted out there that they were using to try to show that Bobby Medford was spending a ton of money that he got from video poker was false. It was just absolutely untrue. The bottom line was they couldn't track any of the money from video poker to Bobby Medford. They just knew a lot of money was coming in from video poker, and it was going somewhere. Our position all along was if it came into the sheriff's department it came into the people who were surrounding Medford—his higher-ups....In fact, the government caught lots of them.*

## A Different View of Medford

Given the conviction and incriminating testimony from multiple witnesses against Medford, it may be easy to come to a quick judgment of Medford's character and his crimes, but Lindsay provides another perspective on Medford's character and the reason why the trial had the outcome that it did. He paints Medford as a sheriff who would open his own wallet to help those in need and someone genuinely concerned about the viability of small businesses in Buncombe County.

"He chose to just not enforce the law. The reason was not because he was benefitting from video poker," said Lindsay. "The reason was this: You've got Walmart in this town. You've got Sam's Club. You've got all these chain restaurants that are coming in and putting the mom-and-pop businesses out of business. The only way many of these places could survive was putting a video poker machine in there."

*In a nutshell, I think Bobby Medford is and was a good, kind, caring human being who, due to his deteriorating health…trusted people that he shouldn't have trusted. There were a lot of people who wound up taking advantage of him and his name and his power. The way [the government] got them to point their fingers at Medford was twofold: One was most of these people had family members working at these stores and businesses where these video poker machines were located. This is the deal that was made with a lot of them: "If you testify against Bobby Medford, we will let your children go*

*free. We will let your spouses go free." So that's one—the government's incentive to cause people to point the finger at Medford and say he was doing all this—that he was the one making all this decisions, which I say he never made, is clear. The second thing was the message from Medford to these people around him, which was also very clear: Do what you have to do to save your family. Not many people know that, but it's the truth.*

Lindsay says the prosecution was willing to go easy on Medford if he would provide other details of corruption in Buncombe County.

"The government really wanted to know about corruption in the district attorney's office and were willing to really cut a very favorable deal for Bobby Medford if he was willing to provide information about what he knew about politicians and politics in Buncombe County and things the government would have considered to be dirty," he said.

*I remember his words to a tee. His response was, "Give them a message from me." I said, "Sheriff, what would that message be?" He said, "Tell them to kiss my goddamn ass." I'm not saying by any means that he knew anything that would bring anybody down. I will say this: asking him to do that offended him to the very core. That is another thing that makes me believe to this day that he is a man of great integrity.*

Of course, not everyone shares that view. Noted *Asheville Citizen-Times* columnist John Boyle offered his published opinion on May 19, 2008:

*Did Medford's lawyers really expect jurors to believe this guy had no idea any of this was going on while the good sheriff simultaneously was pumping thousands of dollars a year into the machines at Harrah's Cherokee Casino? Is Medford so clueless that he thinks wads of cash just appeared in his office magically? And why would the man actually testify? What was at work here? Unbridled arrogance? Greed? Addiction? A sense of invulnerability? To me the case boils down to what my buddy John Emerich Edward Dalberg-Acton, a.k.a. Lord Acton, wrote back in 1887: "Power tends to corrupt and absolute power corrupts absolutely."*

In closing arguments, Attorney Edwards pointed out to the jury that cash deposits into Medford's personal bank account stopped when he lost his bid for reelection in 2006. "No one bribes an ex-sheriff," Edwards said.

Medford is currently scheduled for release on October 11, 2021.

# III

*Arson*

# REMEMBERING ZELDA

*Perhaps 50% of our friends and relatives would tell you in all honest conviction that my drinking drove Zelda insane—the other half would assure you that her insanity drove me to drink.*
*—F. Scott Fitzgerald*

A charred red leather slipper helped investigators identify the body of Zelda Fitzgerald, wife of famed novelist F. Scott Fitzgerald. She burned to death on March 10, 1948, along with eight other women, locked on the fifth floor of Highland Hospital in Asheville. Even if Zelda hadn't been sedated (three others were also given drugs that night to induce sleep), she wouldn't have been able to find a path out of the inferno. Windows were locked; some had heavy chains on them, and the building did not have alarms or a sprinkler system. Corridor doors were held under lock and key. Witnesses could only watch the flames in horror as they listened to the harrowing, desperate cries of the women. One news report said, "Every available piece of the city's fire fighting equipment was called out and off-duty firemen were rushed to the scene. The flames, leaping high into the air, lit a large section of this mountain resort city. About 1,000 spectators, many of them dressed in pajamas, milled helplessly around, unable to assist the trapped women."

The fire began in the diet kitchen and quickly spread up the dumbwaiter shaft. In the second day of a coroner's inquest, nurse Doris Jane Anderson said she discovered the blaze around 11:35 p.m., but she said she was too

Nine women died in March 1948 when Highland Hospital went up in flames. *North Carolina Collection, Pack Memorial Library, Asheville, North Carolina.*

afraid to try to put it out because she had never seen a "destroying fire" before. In her testimony on March 26, 1948, Anderson said the fire was confined to a three- by five-foot table in the diet kitchen when she first came upon the scene. She testified a swath around the edges of the table was the only thing on fire, describing it as having the appearance of "one of those fiery hoops animals jump through in circuses." That table was located about three feet from the dumbwaiter shaft. She also testified that a nearby table holding an electric hotplate and a coffee urn was not burning. She ran to her station on the fourth floor of the building, where she called the fire department.

Fire chief testimony disputed Anderson's claim that it started around 11:35 p.m. Chief J.C. Fitzgerald said that when his crews arrived on the scene at 11:50 p.m. (six minutes after receiving a call), it was evident the blaze had been burning for about forty-five minutes.

Anderson was working on her postgraduate training at Highland Hospital at the time of the fire. She had just started on March 1. She

testified that she was not instructed on the use of fire extinguishers at Highland Hospital or in any other methods of firefighting. She went on duty at 10:00 p.m. and reported that she had personally given sedatives to four patients: forty-nine-year-old Sarah Neely Hipps of Asheville; twenty-eight-year-old Virginia Ward James of Atlanta; forty-nine-year-old Mrs. G.C. Womack of Friendsville, Tennessee; and Zelda, who was forty-eight. Anderson also testified that the sedatives she administered were part of normal hospital protocol.

Around 11:00 p.m. that night, Anderson said night nursing supervisor Willie Mae Hall was on the fourth floor of the building. About twenty minutes later, she said Hall, who had charge of all the buildings at night, left the central building. She testified that she knew the timeline because she wore a watch, and it was her duty to note everything she did and when she did it. She also said that she made rounds about an hour before the fire broke out and went into the diet kitchen. At that time, everything appeared normal.

Witnesses listened helplessly as fire consumed the lives of nine women, including F. Scott Fitzgerald's wife, Zelda. *North Carolina Collection, Pack Memorial Library, Asheville, North Carolina.*

## ACCIDENT OR MALICE?

Was the fire the result of an electrical problem, or could it have been the result of more malicious intent? Anderson's description of the odd pattern of flames encircling a table in the initial stages of the blaze certainly points to something more sinister than accidental. I reached out via email to the granddaughter of F. Scott and Zelda Fitzgerald. Eleanor Lanahan was born within months of her grandmother's death. Her books include *Zelda: An Illustrated Life: The Private World of Zelda Fitzgerald* and *Scottie the Daughter of… The Life of Frances Scott Fitzgerald Lanahan Smith*. She pointed me to a book by Sally Cline, *Zelda Fitzgerald: Her Voice in Paradise*, which details information about how weeks after the fire, Willie Mae Hall turned herself in to police. She told them she "may have" set the fire. She asked them to lock her up because she was afraid of what she might do.

The desk sergeant called in the police chief, district attorney and medical director of Highland Hospital, and they questioned her for six hours. She

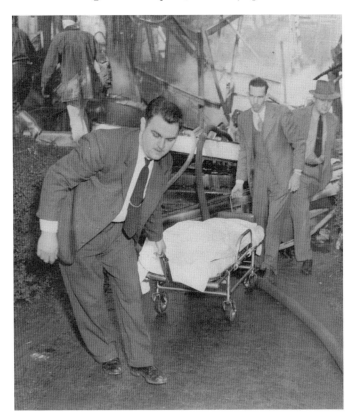

Men in suits wheel remains out of the charred Highland Hospital following a deadly fire in March 1948. *North Carolina Collection, Pack Memorial Library, Asheville, North Carolina.*

reportedly told them, "There are six places in Oak Lodge [a patient building near the fire-destroyed structure] I have picked out that could be set afire. I have thought about it so much and I'm afraid of what I might do and I want you to lock me up." When they asked her if she set the fatal blaze on March 10, she said she didn't know, but she could have. Officers held her at the city jail first and then transferred her to the county jail.

Hall, a native of Jackson, Mississippi, grew up in a Baptist orphanage. After completing high school, she worked in the Mississippi State Sanitarium for twelve years and then moved to Asheville. She had been employed at Highland Hospital for three years.

Superior Court judge H. Hoyle Sink of Greensboro ordered a psychological exam of Hall before she was sent to an institution. Dr. J. Wesley Taylor, a prominent Greensboro psychiatrist, said Hall was in a hysterical state due to the strains of overwork, worry and troublesome dreams. As reported in the *Asheville Citizen-Times*, "Dr. Taylor said Miss Hall told him of having dreams in which patients who died in the fire appeared before her with the complaint that 'she had burned them up.'" In his report, Taylor told the court that he believed Hall was insane but did not believe she had anything to do with the fire at Highland Hospital. She was committed to a mental hospital in Winston-Salem. Arson charges were never filed.

Zelda spent portions of the years 1936–48 as a patient at Highland Hospital. Tragically, doctors told Zelda at the beginning of March 1948 that she was well enough to be released. She made the fateful decision to stay a few more weeks to make sure she was really well.

## DARLINGS OF THE ROARING TWENTIES

Zelda and Scott were known as an IT couple in the Roaring Twenties. Scott's first book, *This Side of Paradise*, debuted to great acclaim in 1920. They married weeks later and became the darlings of the Jazz Age. Known as America's first flapper, Zelda danced on tables, and she and Scott loved being perceived as zany nonconformists. They basked in the fame and financial means of the book success as they traveled, partied and lived the good life. But the good life was really an illusion, as the marriage began cracking with the strains of an excessive lifestyle, insecurities, mental instability and creative competition.

On October 26, 1921, Zelda gave birth to their only child, Frances "Scottie" Fitzgerald. The family moved for a time to Long Island, New York. The addition of a child into the family really didn't change their self-absorbed patterns. They hired a nanny when Scottie was young and sent her to a boarding school in Connecticut when she was older. They moved to France in 1924 because friends told them it was more economical to live there. While Scott worked on *The Great Gatsby*, Zelda focused on her art. She loved creating on canvas as well as writing stories. With Scott preoccupied with his own work, she found companionship in a French aviator named Edouard Jozan after meeting him on the beach near their villa. They swam and danced together, and he performed stunts for her in his plane. Some accounts say they didn't have a sexual relationship, but their association did produce a great deal of jealousy in Scott. His emotions directed his writing, as he crafted stories of adulterous women amid the pages of his novels *The Great Gatsby* and *Tender Is the Night*.

When Zelda was twenty-seven years old, she developed a new focus. She desired to become a professional ballet dancer and began spending up to eight hours a day practicing. In 1928, she received an offer from the Royal Ballet of Italy to dance, but she declined. Her daughter, Scottie, is quoted in *Zelda: An Illustrated Life* as saying, "It was my mother's misfortune to be born with the ability to write, to dance and to paint and then never to have acquired the discipline to make her talent work for, rather than against her."

Zelda suffered her first mental breakdown in Paris in 1930. Doctors diagnosed her with schizophrenia, but others have surmised that she might have had a bipolar disorder. She was a woman who had been a free spirit since childhood. Her uninhibited behavior and her impulsive actions may have caused some to think she was mentally "off," but she likely was not insane. She did struggle with her thoughts and emotions and spent time at a variety of mental health institutions overseas and in the United States, hoping for a solution to save her from her mental demons. She had suicidal tendencies at some times and also went through a period of extreme religious mania.

Writing proved therapeutic for Zelda. She immersed herself in writing short stories, but that created a further crack in her marriage with Scott, as some of her stories were published under his name. In others, publishers added his name to a joint byline to increase sales. Scott also lifted chunks of writing from her journals and incorporated them into his novels. She spent five months writing a novel of her own. *Save Me the Waltz* was published in

1932, but reviews were sharply critical. Zelda and Scott were perhaps drawn to each other as creative spirits. They loved each other, but they also weren't good for each other.

## TIME IN ASHEVILLE

There's a deep fascination about Asheville's connection to noted author F. Scott Fitzgerald and his wife, Zelda. Scott was the first to arrive in Western North Carolina. Suffering from a mild case of tuberculosis, he spent some time in Tryon and Hendersonville before booking stays at the Grove Park Inn in the summers of 1935 and 1936. He was trying to write amid the pressure of accumulating bills for Zelda's treatment and Scottie's schooling. Housekeepers at the Grove Park Inn carried bins filled with beer bottles and wadded up paper from his room—evidence that he was writing some but rejecting his efforts.

Zelda had been spending time at a mental hospital in Baltimore when Scott made the decision to move her to Asheville's Highland Hospital in the spring of 1936. Even thought they did spend some time together, tensions were evident. Zelda's biographer, Nancy Milford, described their outings at the Grove Park Inn:

> *When the Fitzgeralds met it was usually for lunch. They would sit in the dining room far away from the other guests. Scott did not introduce Zelda to anyone and frequently they would sit through an entire meal in silence. After lunch, they walked down the terraced gardens into meadows rimmed with pines and sat on white wicker settees overlooking the mountains, Scott smoking constantly, Zelda lost in silence.*

He was supposed to have lunch with Zelda at the Grove Park Inn to celebrate her thirty-sixth birthday, but the plans were canceled when he broke his right shoulder while doing a swan dive into the hotel pool. He had to wear an enormous cast that wrapped around his body and kept his right arm aloft in an upward salute. He also developed arthritis in that shoulder, adding to his pain and depression. To add insult to injury, a critical account of his life at forty soon appeared in the *New York Post*. Scott was devastated, as he came face-to-face with the realization of how far his life had spiraled down from his heyday. He tried to kill himself by drinking a bottle of morphine, but it only made him throw up.

After that summer, Scott accepted an offer to move to Hollywood and write scripts for Metro-Goldwyn-Meyer for a sum of $1,000 a month, renewable after six months if the producers liked his work. Highland Hospital doctors allowed Zelda to leave for short periods, including visits to her parents in Montgomery, Alabama, during the Christmas holidays in 1938. In February 1939, she joined friends for a month-long getaway to Sarasota, Florida. She also traveled to Cuba with Scott for a two-week vacation that year. He was badly beaten there while trying to end a cockfight. He spent two weeks in a U.S. hospital and then returned home to California and back to the arms of Sheilah Graham. She was the Hollywood gossip columnist he met shortly after moving to the West Coast. They were a couple for three years, even though he remained married to Zelda. He immortalized Sheilah as the inspiration for Kathleen, the female lead in his novel *The Last Tycoon*. She found Scott's body at home when he died of a massive heart attack in 1940. He was forty-four years old. She went on to detail their tumultuous affair in her 1958 bestseller *Beloved Infidel*. Gregory Peck and Deborah Kerr star in the movie version.

Zelda outlived Scott by eight years. A plaque near the site of the deadly fire memorializes Zelda and includes a quote from a letter she once wrote to Scott: "I don't need anything except hope, which I can't find by looking backwards or forwards, so I suppose the thing to do is shut my eyes."

# THOMAS WOLFE HOUSE

*Dixieland was a big cheaply constructed frame house of eighteen or twenty drafty high-ceilinged rooms: it had a rambling, unplanned, gabular appearance, and was painted a dirty yellow.*
—Look Homeward, Angel

In the wee hours of July 24, 1998, the day Bele Chere (Asheville's once famous annual street party) was getting ready to start, someone threw an incendiary device through the first-floor dining room window at the childhood home of famed author Thomas Wolfe. Firefighters quickly reached the scene and frantically worked to douse the flames; they even covered some of the original family furniture with wet blankets in an attempt to save it. While the fire destroyed 25 percent of the rambling twenty-nine-room structure and about 15 percent (two hundred items) of the furnishings, the heroic measures of the firefighters kept the home standing.

Steve Hill served thirty-five years as the historic site manager of the Thomas Wolfe Memorial. He remembers being awakened around 2:00 a.m. on July 24 by the Asheville Fire Department dispatcher who notified him of the blaze. "I said, 'How bad is it?' There was this long, awful pause, and he said, 'You just need to get downtown,'" Hill remembered.

Flames shot through the roof as he arrived and reflected in the windows of the Renaissance Hotel next door. It's something he had always feared—that the house would catch fire.

"When you have a historical structure that's basically a vertical lumberyard, the potential for fire was always on my mind," said Hill.

> *There was no protection sitting right in the middle of town. I always said, "If anything happens, it will be during Bele Chere." We used to get a ton of vandalism during Bele Chere. People would break the trees off even with the ground; one time they picked up bricks out of the sidewalk and tried to break out the door of the visitors' center. One of their favorite tricks—it sounds awful, but it happened—was to urinate through the cracks of the doors from the outside into the lobby. I always dreaded Bele Chere simply because of that. It cost us tons and tons of money every year just to repair the damage from Bele Chere. I could kick myself forever for not having the foresight to put law enforcement on the house during Bele Chere. 20/20 hindsight is a great thing. I wish now I had.*

He tries not to dwell on the wickedness of the act and remembers, with gratitude, how the community jumped into action to help preserve and restore what was left.

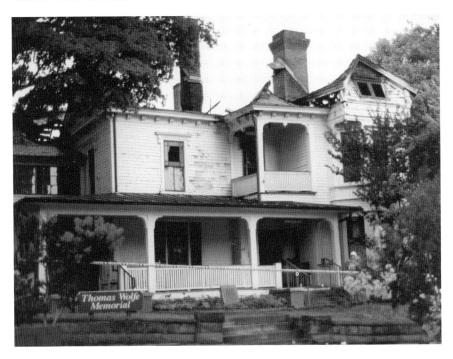

The Thomas Wolfe Memorial still standing after a fire started by an arsonist. *North Carolina Collection, Pack Memorial Library, Asheville, North Carolina.*

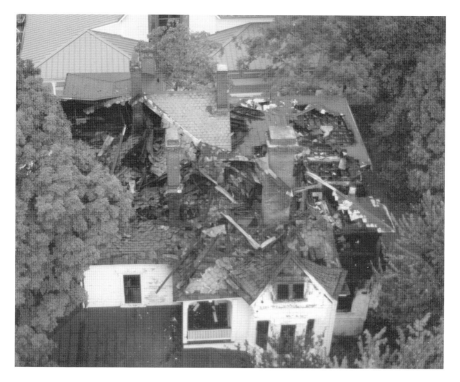

Aerial view of the fire damage at the Thomas Wolfe Memorial. *North Carolina Collection, Pack Memorial Library, Asheville, North Carolina.*

"It was a life changer for me," said Hill.

*It altered my existence, it really did. It happened on my watch. It still hurts. The only thing that got me through the day was when daybreak arrived, Rick King, house manager at Biltmore Estate, sent all of his curatorial staff and all the labor force from Biltmore to us. That was a Godsend. That set the pace of the entire project. It was so efficient. By the time nightfall came on the 24th, all of the artifacts were out of the house, and preliminary cleaning had been done. Chris Peterson (former Asheville City Council member) gave us warehouse space on Market Street so we didn't have far to go to take things to store. One of the things that got me through all of it was the community support that was shown to the Wolfe house. It was phenomenal. We needed all of it. It was a desperate day.*

Waiting for structural assessments to come back felt excruciating to Hill. There wasn't a quick guarantee on the house's fate. "Everything was there

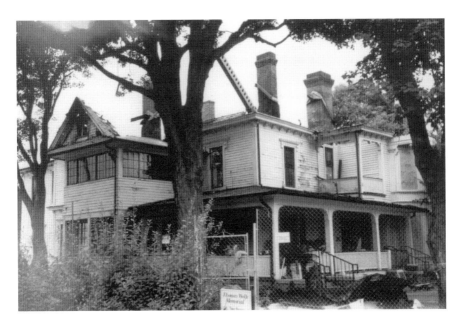

Asheville firefighters were heroic in their efforts to save the boyhood home of Thomas Wolfe. *North Carolina Collection, Pack Memorial Library, Asheville, North Carolina.*

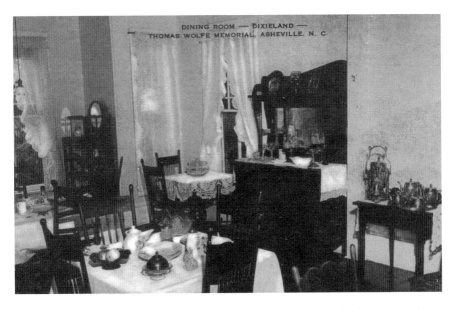

The dining room at the Old Kentucky Home. This room was destroyed when an arsonist ignited the house. *North Carolina Collection, Pack Memorial Library, Asheville, North Carolina.*

except for the dining room and roof," he said. "The toughest time was waiting for reports to come back to find out if we could rebuild or have to tear it down. They finally came to the conclusion that we could restore it."

## THE OLD KENTUCKY HOME

In the late 1880s, a prominent Asheville banker named Erwin Sluder began building a home on Spruce Street for his eldest daughter, Cornelia, and her husband, W.W. Barnard. Construction on the house began in 1883, and the Barnards bought the home on January 13, 1884, for $3,500. From 1884 to 1906, the house changed ownership quite a few times.

As of this writing, there's a growing sense of discontent at the numbers of new hotels being built in Asheville. But this isn't a new trend. In 1910, Asheville had nineteen hotels and a plethora of boardinghouses. Julia Wolfe needed to earn some income, so the thought of running a boardinghouse appealed to her. The going rate for boarders in Asheville was $6 to $14 a week. When Mrs. Wolfe purchased the Spruce Street property in 1906 for a sum of $6,500, it was already being utilized as a boardinghouse known as the Old Kentucky Home and had nineteen boarders who were paying $8 a week.

Six-year-old Tom was the baby of the family, so Mrs. Wolfe took him with her to live at the boardinghouse, leaving her husband, W.O., and other children at the family home on Woodfin Street.

The boardinghouse is the setting for Thomas Wolfe's 1929 blockbuster novel, *Look Homeward, Angel*. The book, labeled as fiction, provides thinly veiled accounts of real people and events in Asheville. He called Asheville "Altamont" in the book and referred to the Old Kentucky Home as "Dixieland." He hurt a lot of feelings with the book and revealed his disdain for the place:

> *Eugene was ashamed of Dixieland.…He hated the indecency of his life, the loss of dignity and seclusion, the surrender of the tumultuous rabble of the four walls which shielded us from them. He felt rather than understood, the waste, the confusion, the blind cruelty of their lives—his spirit was stretched out on the rack of despair and bafflement as there came to him more and more the conviction that their lives could not be more hopelessly distorted, wrenched, mutilated, and perverted always from all simple*

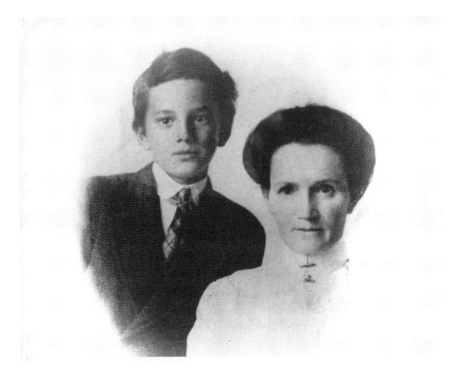

Author Thomas Wolfe and his mother, Julia. *North Carolina Collection, Pack Memorial Library, Asheville, North Carolina.*

*comfort, repose, happiness.... There was no place sacred unto themselves, no place fixed for their own inhabitation, no place proof against the invasion of boarders.*

After the fire, the Thomas Wolfe Memorial underwent a $2.4 million restoration project that took close to six years to complete. It reopened on Memorial Day 2004. "The thing that bothers me most is that we worked hard for funding for upgrades. We were scheduled to close the house in September 1998, take out all the furniture, make repairs, and install an alarm system. We got down to July 24, and we were scheduled to close September 1. We got that close to it. That's always been the irony to me," said Hill.

If Thomas Wolfe was alive to see the restoration project, Hill predicted that "Tom would be horrified. He might have appreciated whoever did it [the arson]." But he thinks Julia would have approved. "Julia was so interested in acquiring property and building. She would be amazed that people would be

so interested in this house. One of the passions of her existence was having people come by and talk about the house and her son and his writings. She would be proud of that."

Before the fire, the Thomas Wolfe Memorial looked and felt just like it did when Julia ran it and boarders and members of her family traipsed through. While the house benefitted from much-needed upgrades that will aid in its long-term preservation, it lost some of its character.

"It was almost all original before the fire," said Hill. "Quite frankly, it never felt the same to me after the fact. Everything was clean and polished and painted and looked a little bit too placed. It looked like a museum more than a historic house, and there is a difference. One of our staff members at the time, Chris Morton, walked in and said, 'It sure doesn't smell like grandma's house any more.' It lost its time-worn patina and didn't feel the same."

Fortunately, there were some valuable artifacts that had been removed and placed in the new visitors' center prior to the blaze. The center opened in October 1997, and staff had moved in the artifacts from W.O. Wolfe's monument shop, items from the family home on Woodfin Street and the typewriter and other personal effects of Thomas Wolfe from his New York apartment. "Those things gained greater importance after the fire because those things are in absolute original shape," Hill said.

The source of the blaze remains a mystery, as no one has ever been arrested. "Hardly a day goes by that I don't wonder where the person or persons are and how they live with themselves. It will be twenty years in July 2018. That's a long time for a cold case to go on," said Hill.

# RICHMOND HILL INN

*The prosecution of this possible crime is our most sincere desire and might help make sense of this horrendous loss.*
*—From a 2009 statement from the ownership of Richmond Hill Inn*

The historic Richmond Hill Inn went up in flames on March 19, 2009. The blaze caused an estimated $7 million in damage to the 120-year-old Queen Anne–style mansion. Investigators quickly labeled it the result of arson after State Bureau of Investigation (SBI) dogs found evidence of a liquid petroleum product at the scene. Investigators also determined that someone turned off the sprinkler system before the fire. No one was staying at the inn at the time because it was closed on winter weekdays.

The inn was in foreclosure at the time and scheduled to be sold because of an unpaid mortgage. In 2005, William Gray, acting through Richmond Hill Inn LLC, agreed to a $10.4 million purchase price from longtime owners Albert and Marge Michel of Guilford County. The Michels financed the mortgage, but tensions erupted when Gray fell behind on payments. As a result, the Michels filed a foreclosure action in October 2008. Gray and investor The Hammocks LLC counter-sued, saying the Michels had failed to disclose plumbing problems at the time of the sale. Buncombe County also sued Gray to collect $64,000 in unpaid 2008 taxes.

In January 2010, Harleysville Mutual Insurance balked on a claim seeking $6 million in insurance payments to cover damage from the fire. In a letter filed with the court, the insurance company maintained that "the fire was

Once the stately home of Richmond and Gabrielle Pearson, an arsonist reduced it to rubble. *North Carolina Collection, Pack Memorial Library, Asheville, North Carolina.*

Broken windows following the fire at Richmond Hill Inn. *North Carolina Collection, Pack Memorial Library, Asheville, North Carolina.*

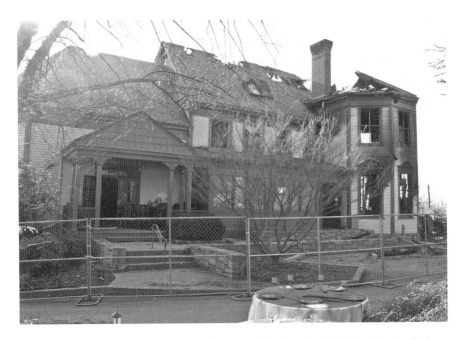

Richmond Hill Inn was in foreclosure at the time of the fire. *North Carolina Collection, Pack Memorial Library, Asheville, North Carolina.*

Remnants of a once beautiful table setting at Richmond Hill Inn. *North Carolina Collection, Pack Memorial Library, Asheville, North Carolina.*

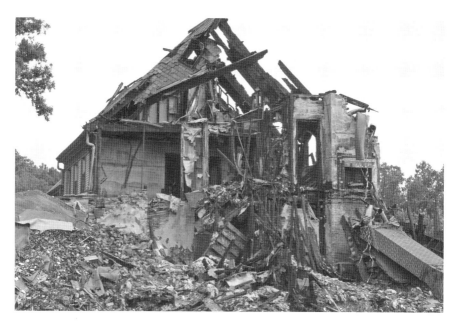

The insurance company denied payment for fire damage. *North Carolina Collection, Pack Memorial Library, Asheville, North Carolina.*

started by a party acting on behalf of The Hammocks." It also said it would not pay for "loss caused by or resulting from criminal, fraudulent, dishonest or illegal acts committed alone or in collusion with another."

After the refusal of insurance, Richmond Hill Inn's website was updated: "Due to vandalism, theft and arson by former employees, Richmond Hill Inn is unable to reopen on April 1, 2010, as planned. We hope to reopen in the future after extensive repairs caused by these problems. We are sorry to disappoint all of our guests who have supported us through the years."

The charred remains of the Richmond Hill Mansion were bulldozed to the ground on February 1, 2012. In August, 2011, Oshun Mountain (OM) Sanctuary, in partnership with RiverLink, announced it purchased the property for $4.5 million.

## GRAY'S BACKGROUND

This wasn't the first time William Gray was embroiled in controversy. The *Asheville Citizen Times* referred to official documents, including court, medical

board, government property documents and bankruptcy papers, in an article published on March 27, 2009: "Gray's background includes time spent on Pacific islands, dalliances into state politics and the loss of medical licenses following allegations he sexually exploited young male patients."

Gray, the son of Baptist missionaries, spent time in a Japanese prisoner-of-war camp in the Philippines. He graduated from the Medical College of Virginia in 1966 and completed one of his residencies in child psychiatry at Duke. He went on to open a child psychiatry practice in Roanoke, Virginia, and served the city's indigent patients. In 1992, he faced misdemeanor sexual battery charges brought by a sixteen-year-old boy who was living in a home Gray rented to the boy's older brother. Gray was cleared of wrongdoing, but a year later, he faced felony indictments on eights counts of sodomy and eight counts of sexually abusing young men and patients. He reached a plea agreement with a prosecutor in Franklin County, Virginia. The state agreed to accept a not-guilty plea in exchange for Gray surrendering his medical license. The Virginia Board of Medicine took it to another level on October 7, 1993. The board refused Gray's offer to surrender the license because authorities thought he would just move his practice to another state. The board decided, instead, to revoke his license because it found he had "unethically exploited the physician/patient relationship by engaging in sexual activities with patients." It also concluded that Gray offered housing, food, money and transportation for sexual favors. Gray reportedly called the whole thing a conspiracy by a group of boys from dysfunctional families, but he eventually surrendered licenses he also held in North Carolina and California.

## HISTORY OF THE MANSION

The grand mansion known as Richmond Hill Inn was originally built as a private residence in 1889 for ambassador and congressman Richmond Pearson. James G. Hill designed the home. Hill had served as the supervising architect for the U.S. Treasury buildings. The impressive home was on the cutting edge of trends in its day—it had running water, a communication system and a pulley-operated elevator as well as a grand entrance hall paneled in rich native oak and ten master fireplaces.

Pearson, a lawyer by trade, enjoyed a successful life of public service. During President Grant's second term in office, Pearson served as U.S.

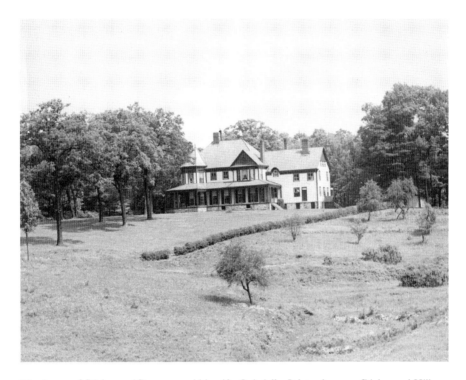

The home of Richmond Pearson and his wife, Gabrielle. It later became Richmond Hill Inn. *North Carolina Collection, Pack Memorial Library, Asheville, North Carolina.*

consul in Belgium. He then returned to his private law practice for eight years before joining the North Carolina legislature. He served two terms and once again returned to his legal practice. In 1895, he ran for Congress and won. He also served as U.S. consul in Genoa, Italy, followed by a stint as envoy extraordinaire to Persia. After that, he served as minister plenipotentiary to Greece and Montenegro.

He and his wife, Gabrielle Thomas Pearson, had four children. The first died in infancy. The second died from scarlet fever at age five. Two other children, Marjorie Noel and James Thomas, were born in 1890 and 1893, respectively. Pearson died in 1923 and his wife in 1924. In 1951, their children opened the mansion for public tours, giving guests a glimpse of the family heirlooms and treasures collected from world travels.

By 1972, the Pearsons' son and daughter had both passed away. Neither had any children, so ownership of the property passed to their cousin General Hayne Davis Boyden. In 1974, he sold the estate to the North Carolina Baptist Homes Inc., with the agreement that the house be preserved for at

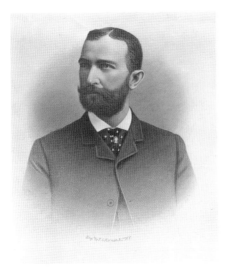 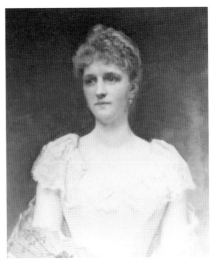

*Left*: Richmond Pearson. *North Carolina Collection, Pack Memorial Library, Asheville, North Carolina.*

*Right*: Gabrielle Thomas Pearson. *North Carolina Collection, Pack Memorial Library, Asheville, North Carolina.*

least a decade. After papers were signed, a weeklong auction was held to sell off the contents of the Pearson home.

The Preservation Society of Asheville and Buncombe County worked hard to find some way to preserve the mansion. Several offers were turned down, but the Baptist Homes ultimately agreed to sell the house to the society for one dollar. But there was a catch. It would have to move the house to a new site—six hundred feet to the east. After a three-year fundraising and grant-seeking effort, the preservation society hired Crouch-Mitch House Moving Company of Asheville to complete the challenging move on November 1, 1984. It was a great success, and the company won a national award for its efforts.

The next goal for the preservation society was to find a buyer who would preserve the home. Dr. Albert and Margaret Michel became the new owners and purchased forty additional adjoining acres that were once part of Pearson's estate. After all the preservation efforts, the loss of the Pearson home to arson serves as an especially sad chapter in Asheville's history.

# IGNITING CONTROVERSY

*This verdict raped firefighters.*
*—Asheville Fire Department captain Jimmy Fox*

Two arson trials in 1992 ignited Asheville's black community, as members called out perceived inequality in the judicial system in Buncombe County. The town witnessed two very different outcomes involving a black man charged with setting fire to an apartment building and a prominent white woman accused of burning her lover's bed. Details of their crimes show two very different sets of circumstances and starkly different decisions.

## CASE OF JAMES RESPER

James Resper was a resident at Oak Knoll Apartments at the time of a blaze there in August 1991 that caused $100,000 in damage. Prosecutors claimed he set a chair on fire as revenge—he was scheduled to be evicted from the complex. Resper maintained his innocence, and friends backed him up, saying he was with them at the time of the fire. There were no eyewitnesses to the blaze. The jury convicted Resper, and the judge sentenced him to thirty years in prison. The thirty-three-year-old Resper said he was railroaded.

While researching Resper's case, I looked up his status on the website for the North Carolina Department of Public Safety. It showed that his criminal record before the arson conviction included common law robbery, simple assault and larceny. His sentence on the arson charge began on February 5, 1992, and he was released on April 11, 2000. I also found his obituary online, detailing his death at age fifty-six on Tuesday, January 19, 2016, at his home in Asheville.

# CASE OF KAREN COULON

In the early 1990s, Karen Coulon greeted a large portion of Asheville's population each weekday morning when they flipped on their TVs. Coulon served as anchor for the morning and noon news at WLOS-TV and won fans with her warmth and pleasing on-air personality. I am in a unique position to write about Coulon's case: at the time, I served as the news producer for the morning and noon newscasts at WLOS. We worked closely together, and I admired Karen's ability to handle any curveball thrown at her during a live newscast. She never missed a beat, even on days when late breaking stories would require me to rapidly rearrange the newscast and notify her of the sudden changes in her IFB (earpiece).

Coulon presented as a stunning beauty with charm to match. She knew she could turn heads, but she also seemed to have bad luck in the romance department. Before coming to WLOS-TV, she worked as the weekend weathercaster for WCPX-Channel 6 in Orlando. She had been married to a dentist—David Moates—but was divorced by the time she arrived in Asheville.

She met John Stahl, owner of Stahlsac, and had a tumultuous relationship with him before breaking up and developing an interest in attorney Bob Haggard. Based on court testimony, Coulon and Haggard had an intimate relationship and had talked of an exclusive partnership. But when Haggard reportedly needed some space, Coulon resisted. He told the court she began showing up at his house the week before the fire at 4:00 a.m. She was due to be on air at 6:00 a.m., and more than once that week, I noted in written newscast discrepancy reports that she arrived and assumed her position in the anchor chair with literally only seconds to spare. The sound guy didn't even get an opportunity to do a mic check on those mornings. I didn't realize until reading through the news articles of the trial and Haggard's testimony

about her 4:00 a.m. visits to his home in Fairview that she was keeping the road hot as she tried to hang on to a dying relationship and still meet the demands of her job.

Karen became enraged when I wrote in one discrepancy report that she arrived to the studio with only seconds to spare before we went live on air. She stormed from the studio to my desk in the newsroom, balled up the report and hurled it at my face while screaming at me. With twenty-five years of hindsight, I can see now how she felt her world was crumbling around her. Of course, at that time, I didn't know of her romantic problems with Haggard. We spent some time that day in the news director's office airing grievances about her late arrivals. Days after this event, Karen called me early on a Saturday morning to apologize for her behavior toward me. She told me that she thought she needed to get back into painting and that she felt like she didn't have an outlet in her life. The next day, August 18, 1991, she went to Haggard's house and, in a fit of jealousy, poured a bag of charcoal on his bed and lit it. She also took some of his clothes outside, where she set them ablaze. She then went back to her apartment in north Asheville and took a nap until investigators rang her doorbell and quizzed her on where she had been that day. She tried her best to cover it up and throw them off—this is something she admitted under oath during her trial. Investigators gathered their evidence, and by the following Saturday, they had enough to formally charge her with second-degree arson.

Following Coulon's arrest, an SBI officer came to WLOS and notified me of a time to appear at the SBI office in Biltmore for questioning. Unnerving, to say the least. As I sat at a long table with a few agents present, they asked me about Karen's demeanor the week at work between the fire and her arrest. Honestly, she didn't seem any different at all. If anything, Karen seemed content and relieved. I thought it was because we had ironed out our differences over her late arrivals to the station. She hid it well. I can't remember all that the investigators asked me, but they put my name on a potential list of witnesses for trial and told me I could go.

Seven men and five women were selected to sit on the jury for her March 1992 trial. Judge Robert Kelly—the same judge Resper faced—presided. Coulson, who was thirty-six at the time, wore her hair in a bun, dressed conservatively and directly appealed to the jury when she took the stand. Shockingly, she admitted everything. She detailed her anger and intensified jealousy as she listened to another woman leaving Haggard a message on his answering machine. She also found a woman's hair barrette in his bed.

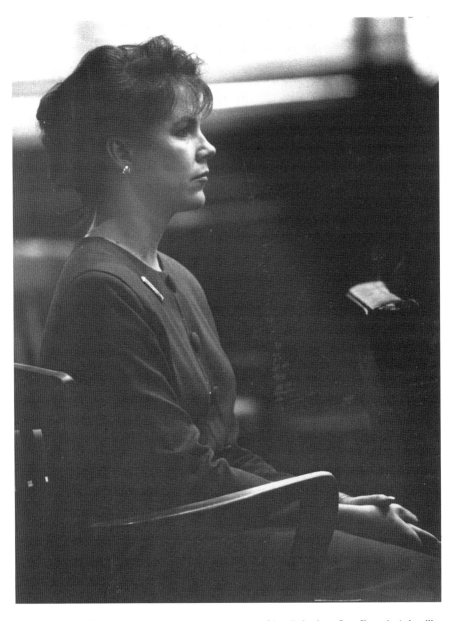

Former WLOS-TV anchor Karen Coulon set her boyfriend's bed on fire. *From the* Asheville Citizen-Times.

"I was shocked," Coulon told the jury. "I knew he had made love to someone else there. I cried so hard I could not see straight for a while." She then detailed how she grabbed a bag of "instant light" charcoal from the back porch, dumped it in his bed and dropped a lit match on it. She then took some of his clothes outside, where she doused them with lighter fluid in the driveway and set them on fire. She also admitted shattering beer bottles and one of Haggard's framed diplomas. "I was so trusting, and Bob never gave me the chance to protect myself adequately," Coulon said. She assured the jury that she never intended to burn the house down. She claimed she only wanted to burn the bed. The fire caused $40,000 worth of damage—firefighters were able to contain it to the bedroom.

The seven-woman, five-man jury returned after only deliberating for two hours and handed down a "not guilty" verdict. Prosecutors in the case call it a "sympathy verdict." The *Asheville Citizen-Times* quoted Asheville Fire Department captain Jimmy Fox as saying "This verdict raped firefighters." It also quoted a reaction from then district attorney Ron Moore: "The judge was astounded about the Coulon verdict. We were astounded that she admitted what she did. But it appears the jury thought she intended to burn the bed and not the house." Coulon gushed with relief: "It is very reassuring to me. The system has been put through all its paces, and it worked for me. It is so hard for me to say how grateful I am. I think everyone understood how sorry I am."

Following her arrest, I never had another conversation with Karen. I fully believe she thought she would be welcomed back to WLOS with open arms because of her acquittal. I watched as she pulled into the parking lot at the WLOS studio on Macon Avenue. She went upstairs to meet with general manager Jim Conschafter, and after a time in his office, she descended the stairs and walked out the front door, never to return to her $44,000-a-year job. She got into her red BMW and drove out of sight.

Meanwhile, James Resper sat in jail.

## BLACK COMMUNITY PROTESTS

After the stunning decision in Coulon's trial, Kenneth Brantley, president and general manager of WKDB-FM, organized the Coalition for Equal Justice Under Law. Its goal was to "assure equal justice by judges, juries and officers of the court, for men, women, and children of all races and ethnic groups."

He was quoted in the *Asheville Citizen-Times* as saying, "Buncombe County has no black public defenders, prosecutors, or judges. If you look at the people who have the power in the judicial system locally, the numbers do not reflect the composition of the community racially or sexually. I don't think that guarantees the kind of empathy desired in cases involving blacks."

## DEADLY UNSOLVED ARSON

On July 28, 2011, flames broke out in a medical center building located at 445 Biltmore Avenue directly across from St. Joseph's Hospital. Captain Jeff Bowen, a thirteen-year veteran of the Asheville Fire Department, was one of the first to rush into the burning building. He was on the third floor when he sent out a distress signal while searching for people to evacuate. There were about two hundred people in the building at the time. The building didn't have any sprinklers. Overcome by the heat and smoke, the thirty-seven-year-old Bowen went into cardiac arrest and died at Mission Hospital. It was the first time in almost thirty years that an Asheville city firefighter died in the line of duty. Investigators determined the fire was started by an arsonist, but the case has never been solved.

# IV

*Wicked Diseases*

# TUBERCULOSIS

*Asheville is cleaner, and healthier now than ever before. No efforts will be spared to keep the city clean and healthy.*
—*Asheville mayor H.S. Hawkins, September 13, 1888*

A wicked disease played a vital role in promoting Asheville and accelerating its growth. Tuberculosis, also known as the white plague, brought many people to the Asheville area because of its growing reputation in the late 1800s as a health resort. In the late nineteenth and early twentieth centuries, tuberculosis led to many fatalities. It reached epidemic levels throughout Europe and the United States in the mid-1880s and was the leading cause of death at that time. The disease eats away at the lungs, producing hacking coughs, bloody phlegm, fever and a weaker, debilitated state. Even though it was misery and agony for those suffering—as they became thin and slowly wasted away with consumption—the general view of tuberculosis in this period was that it was a "romantic disease." Victims were seen as attractive with their pale appearances, and the disease played a role in classic novels such as *David Copperfield* and *Wuthering Heights*, along with TB images in art and poetry. Claude Monet painted his TB-suffering wife on her deathbed. English poet John Keats watched the disease claim several family members. Edgar Allan Poe wrote a poem about a woman dying of TB and also lost his wife to the disease. The romantic view is that suffering proved inspirational to artists who found increased creativity amid pain.

Asheville came into the mix as doctors began to tout the benefits of a higher altitude and clean air as the perfect climatic combination to recover from the illness. The vast majority of patients who came to Asheville seeking a reprieve died within five years.

In 1871, Dr. Horatio Page Gatchell opened the first tuberculosis sanitarium in the United States in Asheville. It was called the Villa and located in what's now the Kenilworth neighborhood. Gatchell had an impressive medical career that included education at the Bowdoin College of Maine followed by time working in Cincinnati, Cleveland and the Hahnemann Medical College in Chicago. Gatchell heard about Asheville's healing climate in the late 1860s and moved to town to experience the conducive climate for himself. He worked with real estate broker E.J. Aston (who later became Asheville mayor) to create a pamphlet that boasted the advantages of Asheville's climate titled "Western North Carolina—It's Agricultural Resources, Mineral Wealth, Climate, Salubrity and Scenery." Gatchell's sanitarium preceded the 1875 opening of Mountain Sanatorium in Asheville by Dr. Joseph Gleitsmann. Both men were ahead of their time with their sanitariums, but they set the stage for Drs. Karl Von Ruck and Samuel Westray Battle, who arrived in Asheville in 1885 and 1886, respectively, and made their mark in the area of TB treatment.

# KARL VON RUCK

Asheville became the chosen home of Dr. Karl Von Ruck in 1888. He was already a highly regarded tuberculosis expert who had worked under Professor Robert Koch in Germany. Koch discovered the germ that caused tuberculosis and went on to develop an inoculation method. Von Ruck, a native of Constantinople, Turkey, earned his undergraduate degree in Germany in 1867. After an interruption by the Franco-Prussian War, he completed his medical degree in 1877. His path led him to England and then to the United States, where he earned a second medical degree at the University of Michigan.

When he heard the buzz about Asheville's healthy climate, he came into town and established the Winyah Sanitarium, modeled after those in Germany. It was located at Baird and Pine Streets in north Asheville, but in 1900, he built a new facility on Spears Avenue. It included a farm and

*Right*: Tuberculosis pioneer Dr. Karl Von Ruck. *North Carolina Collection, Pack Memorial Library, Asheville, North Carolina.*

*Below*: Winyah Sanitarium opened by Dr. Karl Von Ruck. *North Carolina Collection, Pack Memorial Library, Asheville, North Carolina.*

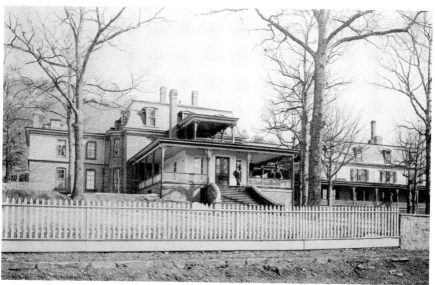

dairy—that land is now the location of the U.S. Forest Service Southern Research Station.

In Asheville, he published the *Journal of Tuberculosis*, which grew from a small 48-page publication to a 120-page journal. It was the only journal in the United States exclusively devoted to the topic of tuberculosis.

# DR. S. WESTRAY BATTLE

With the arrival of the railroad to Asheville in 1880, travel to this beautiful mountain town became easier, and as a result, more physicians came—as well as wealthy patients. Dr. S. Westray Battle arrived in Asheville in 1885 and played a huge indirect role in building Asheville as the powerhouse tourist destination it is today. It's because of his reputation as a leading physician that George Vanderbilt came to town with his ailing mother. They stayed at the original Battery Park Hotel, and as Vanderbilt stood on the porch of that luxurious hotel, he gazed out at the mountains surrounding Asheville and quickly purchased 125,000 acres. He then launched plans to build his palatial Biltmore House. E.W. Grove, another man who marked

The home of Dr. S. Westray Battle on Macon Avenue later served as the studios for WLOS-TV. *North Carolina Collection, Pack Memorial Library, Asheville, North Carolina.*

Dr. S. Westray Battle, esteemed Asheville physician. *North Carolina Collection, Pack Memorial Library, Asheville, North Carolina.*

Asheville with his name and his wealth, also came to town in order to receive treatment from Dr. Battle. In 1909, Governor Craig appointed Dr. Battle as the surgeon general of the North Carolina National Guard.

Dr. Battle's mansion was located on Macon Avenue next to the Grove Park Inn. It later served as the studios for WLOS-TV before it was demolished. The site now boasts the luxurious Fitzgerald Condominiums at Grove Park Inn.

# DR. JOHN WAKEFIELD WALKER

Asheville's black population received a boost in tuberculosis treatment in 1912 when Dr. John Wakefield Walker created the first healthcare facility in Asheville to treat African American TB patients. He was also the first black pulmonologist in the country. In 1916, the Asheville telephone book featured an ad that described Circle Terrace Sanatorium:

*This is believed to be the only institution in the world for the exclusive treatment and care of tuberculosis for COLORED PEOPLE. Situated in the most perfect all-the-year-round climate that can be found for the treatment of tuberculosis. The Sanatorium is conducted under the strict sanitary laws of the City of Asheville. Electric lights, call bells, telephone, baths and other modern improvements. Ample porches with south-eastern and south-western exposure. Moderate rates. Mrs. Carrie Robinson, an experienced nurse, manager. For further information, apply to J.W. WALKER, M.D.*

Circle Terrace Hospital closed in 1917, and Dr. Walker took a position in Hoke County, North Carolina, with the new Negro Division of the State Tuberculosis Sanitarium. He returned to Asheville three years later and set up his private practice.

## GAINING CONTROL

There was a fine line to walk in Asheville. With tuberculosis patients arriving in large numbers for treatment and a restorative climate, there was an economic boom for finding places to house them. At the same time, residents of Asheville wanted to make sure they could stay healthy amid all the sick visitors. Asheville officials responded in 1896 by making it illegal to spit on sidewalks or in public buildings.

With the development of antibiotics in the 1940s, tuberculosis declined as a public health concern. Asheville's proliferation of sanitariums went through a transformative phase. Some closed; others were repurposed, such as St. Joseph's Sanitarium, which became St. Joseph's Hospital.

❧ A summer spent in the "Land of the Sky" is a genuine investment in health.

❧ Asheville's elevation is 2500 feet, Asheville's scenery is remarkable, Asheville's summers are cool, Asheville's water is pure.

Doctor Carroll's Sanitarium is an institution employing all rational methods for the treatment of Nervous, Habit and mild Mental Cases; especially emphasizing the natural curative agents — Rest, Climate, Water and Diet.

ROBT. S. CARROLL, M. D.
Asheville, N. C.

Ad touting Asheville as a health resort. *North Carolina Collection, Pack Memorial Library, Asheville, North Carolina.*

# SPANISH INFLUENZA 1918–19

*The epidemic of influenza is sweeping Asheville....More Asheville people are dying of influenza at home than are dying from all causes on the battlefields of France.*
*—published ad calling for volunteer workers during the Spanish flu pandemic of 1918*

One of the most memorable scenes in *Look Homeward, Angel,* is the death of Ben Gant, who becomes a victim of the Spanish influenza pandemic of 1918. Thomas Wolfe was writing about the real-life death of his brother, Benjamin Harrison Wolfe, who died just days short of his twenty-sixth birthday. He was unmarried, didn't have any children and was employed by the *Asheville Citizen* in a dead-end job. His twin brother, Grover, died fourteen years earlier of typhoid fever. Ben's death deeply impacted Tom's life, as he related in a letter to his sister Mabel:

*I think the Asheville I knew died for me when Ben died. I have never forgotten him and I never shall. I think that his death affected me more than any other event in my life....Ben—he was one of those fine people who want the best and highest out of life, and who get nothing—who died unknown and unsuccessful.*

# Killer Flu

The Spanish flu pandemic of 1918–19, known as the deadliest in modern history, sickened an estimated 500 million people worldwide. To put it in perspective, that was about a third of the total global population at that time. More than a quarter of people in the United States became sick, with more than 650,000 Americans dying. Worldwide, it's estimated the flu killed between 20 million to 100 million. The vast discrepancy lies in the fact that there wasn't adequate record keeping in some areas. In North Carolina, statistics reveal that 20 percent of the state's population fell victim to the flu between 1918 and 1919, with the death toll nearing 14,000.

There's great debate in today's world about whether to take a flu shot, but it wasn't an option in 1918. The first flu vaccine appeared in America in the 1940s. Doctors didn't have any drugs that would treat the Spanish influenza. Symptoms included extreme fatigue, fever, nausea, aches and diarrhea, and in many cases, it rapidly evolved into severe pneumonia. Reports say the skin of those afflicted would start turning blue. Strangely, this strain of flu seemed to target those who were young and healthy; many victims died within hours of the first symptoms, while others died within a day or two.

A poem published in the May 4, 1919 edition of the *Asheville Citizen-Times* provides a rhyming glance at what this ferocious flu felt like. It was attributed to a man named Dick Micks:

*Have You Had it?*
*When your back is broke and your eyes are blurred,*
*And your shin bones knock and your tongue is furred,*
*And your tonsils squeak and your hair gets dry,*
*And you're doggone sure that you're going to die,*
*But you're skeered you won't and afraid you will,*
*Just drag to bed and have your chill,*
*And pray the Lord to see you through,*
*For you've got the Flu, Boy,*
*You've got the Flu.*

*What is it like, this Spanish Flu?*
*Ask me, brother, for I've been through—*
*It is Misery, but of Despair;*
*It pulls your teeth and curls your hair;*

*It thins your blood and brays your bones,*
*And fills your craw with moans and groans,*
*And sometimes, maybe, you get well.*
*Some call it Flu—I call it hell!*

# Spanish Flu in Asheville

Schools, churches and theaters in Asheville all closed their doors as the Spanish flu began to spread westward after showing up in Wilmington. The *Asheville Citizen* reported on October 5, 1918, that eight thousand cases of Spanish influenza had been reported in North Carolina. On October 13, the *Asheville Citizen* put out an emergency call for volunteers:

> *The epidemic of influenza is sweeping Asheville. Our people are suffering for lack of attention as never before. More Asheville people are dying of influenza at home than are dying from all causes on the battlefields of France....[T]his emergency call is issued for doctors, nurses and workers both white and colored to keep people in Asheville from dying from starvation and lack of other attention.*

The October 22 issue of the *Asheville Citizen* reported that the Red Cross Influenza Committee had established two emergency hospitals for flu victims. The old city high school on Woodfin Street was selected as one site and equipped with fifty hospital beds. The second location was at the Masonic Temple—it became a hospital for inflicted members of Asheville's African American community.

An article on October 23 touted Vick's VapoRub for those suffering with the Spanish flu. It read, in part:

> *Most authorities now agree that what we call Spanish Influenza is simply the old-fashioned grip, which was epidemic here in 1889–90.... The use of VapoRub does not interfere with any internal treatment and it is now being used by broadminded physicians everywhere, in order to stimulate the lining of the air passages to throw off the grip germs, to aid in loosening the phlegm and keeping the air passages open, thus making the breathing easier.*

It also notes that Vick's VapoRub is "the discovery of a North Carolina druggist who found how to combine, in salve form, Menthol and Camphor with such volatile oils as Eucalyptus, Thyme, Cubeba, etc."

An Anthony Bros clothing store ad appeared on the same page, reflecting on the lack of customers due to people staying home and away from crowds:

*Getting Accustomed*

*We can get accustomed to almost anything in the world—EVEN THE INFLU*

*The tremendously small percentage of deaths to the number of cases in Asheville has taken the sting and dread out of the ASHEVILLE FLU.*

*You can hear it on all corners of the street.*

*Business is fast becoming normal (with us, anyway). The excitement, if there was any, is all gone. In a few days, Asheville will be herself again and everybody happy. If good wishing and optimism will help any we are giving the Flu an awful hard kick downhill.*

# ASHEVILLE'S POLIO EPIDEMIC

*I pictured myself as a virus or a cancer cell and tried to sense what it would be like.*
*—Dr. Jonas Salk*

I've often thought of the fear my dad's sister, Frances Anne Midyette, must have faced when she was diagnosed with polio, also known as infantile paralysis. She died in Asheville on July 6, 1948, surrounded by medical personnel. She was fifteen years old.

"She got sick and died in four days," my dad, Ray Hardee, remembered.

> *There was a polio epidemic in North Carolina, and she got to feeling bad. They put her in the old Asheville Orthopedic Hospital [where CarePartners is now]. I remember going there with my grandmother, and my grandmother came out and said, "She's gone." You talk about tragedy—she never had a chance. Those doctors worked on her tooth and nail to keep her alive. They tried. To go from feeling good to being dead in four days—that's something that was really working on you. Right before she died, she was in the bedroom at home, and I drank from the same glass. They watched me for a long time to see if I'd catch it.*

My dad was seventeen at the time, but thankfully, he never showed any signs of polio.

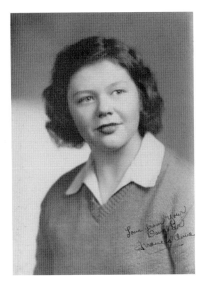

Frances Anne Midyette died of polio at age fifteen. *Author's collection.*

My aunt's death was reported in an article in the *Asheville Citizen-Times*. It read: "Two deaths have resulted from polio here and three additional cases were reported to the city health department yesterday, bringing the city and county total of cases this summer to 12. Frances Midyette, 15, of 5 Sawyer Street, died early yesterday morning and four-year-old Jimmy Whitt died Sunday."

By August, many Asheville families were staying close to home and avoiding crowds. City officials banned all public gatherings. A news report from August 2, 1948, stated: "Streets, swimming pools and even churches were silent Sunday, and this resort city's million-dollar tourist business faded away. The last report placed the number of polio cases in the state for the year at 1,095."

Officials quarantined all Buncombe County children under the age of sixteen for a time. They were set to lift the ban on August 18 but canceled that plan when four new cases were reported. The numbers of those afflicted began to decline, and by mid-September there were only two active cases of polio in Asheville.

Fever was a customary first symptom of polio, followed by headache, vomiting, diarrhea in some cases and potentially paralysis. Death would occur due to respiratory paralysis. Some patients survived but were left crippled by the disease. Other cases of polio were milder.

## ELIMINATING SWEETS

In the height of the epidemic, an Asheville doctor advised that people should eliminate sugars and starches from their diet in order to ward off polio. Dr. Benjamin P. Sandler was a former navy doctor and served as a physician at the Veterans Hospital in Oteen. Sandler, recognized as an expert in nutrition research, was the first doctor to transmit polio to a rabbit. The tests he conducted in 1938 involved lowering the rabbit's blood

sugar for four to six hours and then exposing the animal to the polio virus. Rabbits were thought to have an immunity to polio, but with the lowered blood sugar, the animal became a quick victim to the disease. Even though it sounds paradoxical, Sandler theorized that the major cause of polio in humans (particularly younger age groups) is low blood sugar caused by eating too many sweets and starchy foods.

He offered up a "polio immunization" diet to help people avoid the disease. The forbidden foods included soft drinks, fruit juices (except tomato juice), canned and preserved fruits, ice cream, pastries, pies, candy and starches like bread, rolls, rice, cereals, grits, pancakes and potatoes. "Cut out those foods and in one day's time the body builds up sufficient resistance to ward off the polio virus," said Sandler. "I am willing to state this without reserve."

He recommended three square meals a day with an emphasis on eating meats, fish, poultry, milk and milk products. He also advised replacing starches with tomatoes, string beans, cucumbers, greens, carrots, red beats, cabbage, onions and soybeans—fresh fruits only one time a day. He also advocated plenty of rest.

# POLIO VACCINE

In 1947, Dr. Jonas Salk turned his attention to finding a way to stop polio in its tracks. He became head of the Virus Research Lab at the University of Pittsburgh. This followed time spent at the University of Michigan School of Public Health, where he was part of a team working to develop a flu vaccine. It took him several years to pinpoint three distinct types of polio viruses. He worked on developing a "killed virus" vaccine using laboratory-grown polio viruses that were destroyed.

Preliminary testing of the vaccine began in 1952 and expanded over the next two years, making it one of the largest clinical trials in history. The participants became known as the "Polio Pioneers." Salk said, "My own children were the first to receive inoculations soon after I began tests on human beings." An estimated 1.8 million children received the vaccine during the expanded test phase, and when it proved successful—in 90 percent of cases—Salk became a national hero.

In April 1955, Salk's vaccine was determined to be safe and effective for the general population. Soon after, mass inoculations took place in

schools around the country. The *Asheville Citizen-Times* reported on April 13, 1955, that a mass inoculation of Buncombe County children in first and second grades would start before the end of the month. The vaccine was provided for free by the National Foundation for Infantile Paralysis. More than 6,000 students were eligible, and the paper reported that parental permission had already been received for 4,620 children.

Salk could have raked in millions for his vaccine, but here's an example of a man who understood the value of aiding humanity. He wanted the vaccine to be widely available, so he never patented the vaccine or earned any money from his discovery.

The next step in Salk's career involved launching the Salk Center for Biological Studies in 1963. He joined other scientists in the study of such diseases as cancer and multiple sclerosis. In later years, Salk focused on AIDS and HIV. Salk died of heart failure in 1995 at the age of eighty. He will always be remembered as the doctor who stopped polio.

# STRANGER THAN FICTION

*Sidney Lascelles' body now awaits a claimant at Asheville, N.C., having been identified as that of the bogus Lord Beresford, who swindled many society women, marrying one after another, as he went from place to place.*
*—newspaper report, 1907*

An Englishman who arrived in Asheville in 1902 hoping to find relief from an illness became a bizarre part of Asheville history after his death a few weeks later. He arrived by train and checked into an upscale boardinghouse on Montford Avenue. He introduced himself as Mr. Charles J. Asquith and was dressed stylishly in an expensive suit with ascot tie and bowler hat. He also had a Vandyke-style beard and a chronic cough—a telltale sign of tuberculosis. People in town speculated about this visitor. Word traveled through the local grapevine that he was connected to English nobility.

He died a short time after arriving in Asheville, and his body was taken to the Noland-Brown Funeral Home on Church Street, where it was embalmed. The mortician, Claude Holder, sent telegrams to England to try to locate the man's relatives, but no one came forward. They found only five dollars in his possessions—a paltry sum that wouldn't come close to paying his funeral costs. He had traveled to Asheville in the company of a nurse who stayed with him until his death. The five dollars was given to her.

Days turned into months. Months turned into years, and it became increasingly apparent that the body would be hanging around at the funeral

home. Some creative marketing ideas provided a way to press the corpse into service as an advertisement. The mortician would occasionally take it out in a surrey and parade it around town. Some people may have been horrified to see a dead body carted around town, but others were amused and began referring to it as "The Duke." Other times it would be on display in the front window of Noland-Brown as an example of superior embalming expertise. It's reported that even eight years after the mystery man's death, his body looked as natural as when he was alive.

There were also a few moments of pranks as friends would gather at the funeral parlor on some late nights for a few rounds of stud poker. They'd prop the Duke up as another player at the table—he was certainly expert in keeping a poker face. Another time, when the body was placed in a desk chair in an upstairs office, staff directed a black man seeking employment to go talk to the man upstairs. After a short time, they heard the man let out a yell and then he fled down the stairs and out the front door.

In 1907, some of the missing details of the man's life were provided by a prominent attorney from New York who was visiting Asheville. He spotted the embalmed body of the man he knew as "Lord Beresford" standing on a pedestal in the funeral parlor and looking the same as he had in life. A newspaper account from May 17, 1907, read, "The gentleman had no doubt of his identity as he knew him well, having represented him…during his various trials in Rome (Georgia), and saw him every day for many months." The same newspaper article reported the undertaker said that since he had been exhibiting the body, "no less than six different women had appeared claiming that he had married them under different names, taken their money and disappeared. They all wanted his body."

A museum also set its sight on the mummified body. In 1907, it offering the funeral home $2,000 for the body, which it wanted to put in an exhibit, but the funeral home declined the offer.

In May 1910, a woman by the name of Mrs. T.J. Summerfield was ready to open her purse strings to claim the body. She said she was the sister-in-law of Sidney Lascelles (a.k.a. Charles J. Asquith, a.k.a. Lord Beresford and many other names). She signed an affidavit, paid $150 for embalming services and posted a $2,000 bond, which was quite a hefty sum in 1910. She had the body loaded on a Southern Railway train headed to Washington, D.C., for cremation and burial. The body was reduced to ashes on May 19, 1910, at the crematory of J.W. Lee. Strangely, no one came to pick up the ashes.

The *Washington Post* reported, "While Mrs. Summerfield, or Mrs. Watson, as she was known here, left for Washington with the body, there is no clue

to her whereabouts. Mrs. Summerfield carted letters from the first wife of Lascelles, authorizing her to get the body and ship it to Washington. These letters spoke in endearing terms of the deceased, and described her three years of married life with Lascelles."

## WHO WAS SIDNEY LASCELLES?

The tale of a man named Sidney Lascelles is so intertwined with deception, romancing women from rich families, jail sentences, aliases and tales of his adventures that books could be written about him alone. He even wrote his own book while serving a sentence in a Georgia lumber camp. It was titled *Lord Beresford's Book: From Wealth and Happiness to Misery and the Penitentiary*. It was printed serially in a wide number of newspapers, including the *Asheville Citizen*.

Lascelles was born in England in 1857, and when he turned nineteen, he decided against entering the service of Her Majesty the Queen. His father used his connections to get Sidney a job at a conservative banking house in London. His mundane life as a bank clerk was pretty normal for the first six months, but then he started doing some stock investing of his own. When he saw results, he decided to team up with a partner to increase the amount and the rewards of his speculation. He also began risking large sums of money on horse racing and other events. But when the bank found out what he was doing, managers told him he could resign.

He left England and traveled to India. Armed with some high-level recommendations from his connections, he was easily accepted into Calcutta society. He traveled widely, hobnobbing with the rich and influential and continuing his penchant for gambling and deceit. When his luck started running out, he set sail for America. On a ship headed to New York, he met Maude Leslie, who was traveling with her mother. He quickly proposed, and in February 1891, she became Mrs. Sidney Lascelles. He soon took on the "Lord Beresford" alias because he had an uncanny resemblance to "Condor Charlie," the real Lord Beresford. During a trip to Atlanta, he freely wrote checks bearing the Beresford coat of arms but was arrested when they all bounced. He was sentenced to six years in a lumber mill prison camp at Kramer, Georgia. Even as a prisoner, he rose to a position in mill management and wrote his book in diary form during this period. It was published with the backing of South Georgia businessmen.

Lascelles was released early and wound up in Fitzgerald, Georgia. Using his own name this time, he rented out a building at the center of town, filled it with desks and typewriters and hired about a dozen stenographers. This was done despite the fact that Lascelles was broke. He used his charm and influence to gain credit. He sent letters to manufacturers announcing his new commission business and invited them to send samples. The letters, sent out on finely embossed stationery, produced amazing results—manufacturers began sending box loads of items, and soon his building was filled. He then invited prominent businessmen in the community to attend a grand opening. He greeted them with cigars and other items received as samples. He quickly established himself as a reputable businessman in town. His scam didn't last long. He sold all he could, pocketed the cash and never remitted payment to the manufacturers. He fled town, along with the daughter of Alexander Pelkey, one of the wealthiest men in Fitzgerald. Pelkey changed his will to remove his daughter from any inheritance because he feared Lascelles was using her as a means to get his hands on the family money. Tragically, Pelkey died suddenly, leaving his will unsigned. By all accounts, Lascelles had multiple wives, all duped into marriage so he could swindle them out of their money.

The next stop for Lascelles was Texas. He showed up in a border town and told people he was an English mining and chemical engineer "who had perfected a compound, which would render gasoline non-explosive and thus greatly facilitate its handling." Investors put up money, and a company was formed. The money began to roll in, and once again, the "easy money prince," as he's been called, converted all of the assets of the company to cash and disappeared. He turned up in a small California town and wound up behind bars on a fraudulent bond deal. When he was released from prison, he was an ailing man. He turned his focus to regaining health and moved to Asheville for a very brief time until his death—seated by an open window while gazing out at Mount Pisgah in the distance.

# BIBLIOGRAPHY

*Akron (OH) Beacon Journal*. "Four Banks Close Doors in Carolina." November 20, 1930.

*Asbury Park (NJ) Press*. "Martin Moore Is Executed for Helen Clevenger Death." December 11, 1936,

*Asheville Citizen-Times*. "Abandoned Woman's Body Identified." February 16, 1987.

———. "The Amazing Story of Lord Beresford Ended Here." March 26, 1950.

———. "Arson Evidence Found: Investigators Take Note of Richmond Hill Foreclosure." March 21, 2009.

———. "Arthur E. Rankin, Former Bank Official, Takes Own Life." February 18, 1931.

———. "Art in Asheville (Mark Wollner)." April 14, 1963.

———. "Asheville Continues Quarantine for Polio." August 18, 1948.

———. "Asheville Doctor Established the Country's First TB Sanatorium." September 10, 2001.

———. "Asheville Long Known as a Health Resort." June 17, 1940.

———. "Asheville Pioneered in Health Measures." March 26, 1950.

———. "Autopsy Shows Victim of Serial Killer Strangled to Death." September 21, 1990.

———. "Avalanche of Ballots Rides Prohibition on Crest of Victory's Wave." October 9, 1907.

———. "Bankers Confident Asheville Crisis Is Passed." November 21, 1930.

———. "Bank Officials Arrested on Federal Warrants." February 5, 1931.

———. "Blacks Angry at Acquittal of Coulon: Judicial System Accused of Double Standard." March 21, 1992.

———. "Brave City Officers Fall Dead on Streets Acting in Line of Duty: Negro Runs Amuck on Asheville's Streets, Killing Patrolmen Blackstock and Bailey and Wounding Captain Page; One Negro Killed and Two Wounded." November 14, 1906.

———. "'Brutal' Slaying of Styles Rattled WNC Residents." April 4, 1998.

———. "Central Bank Affairs Taken Over by the State." November 21, 1930.

———. "Clevenger Is Highly Regarded as Teachers, Aver His Associates." July 25, 1936.

———. "Codds Recalled: 'My Heart Just Ripped in Half.'" March 17, 2015.

———. "Coulon, Resper Cases Hotly Debated: Community for Calls for Monitoring of County Justice System." March 29, 1992.

———. "Coulon Says Fit of Anger Led to Burning Bed." March 19, 1992.

———. "County Reports One Polio Case in Emma Section." September 15, 1948.

———. "Court Officials Await Psychiatrist's Report in Highland Nurse Case." April 15, 1948.

———. "Current, Former Owners Locked in Legal Dispute." March 20, 2009.

———. "Diet Is Major Factor in Polio Prevention, Dr. Sandler Believes." August 5, 1948.

———. "Dog a Living Link to Quinn Cold Case." April 20, 2017.

———. "Dramatic Appeal Made to Frightened Crowd by Banker Helps Check Run." November 21, 1930.

———. "18 Bankers and Municipal Officials Indicted by Grand Jury to Face Trial at Special Term." February 22, 1931.

———. "Ex-Buncombe Manager Wanda Greene Pleads Not Guilty to Money Laundering, Wire Charges." June 13, 2018.

———. "Expert: Warren Abused as Child." October 4, 1995.

———. "Explains Suicide in Letter; Pleads for Peace in Asheville." February 25, 1931.

———. "Ex-Sheriff, 3 Former Assistants Face Sentencing in Gambling Cases." October 5, 2008.

———. "Facts Hinder Solution of Helen Clevenger Murder." August 2, 1936.

———. "5 Dead in 20 Minutes: Murders in Downtown Asheville." November 12, 2006.

———. "Flashback: Gunman Leaves a Trail of Death." February 15, 1987.

———. "Gallatin Roberts Shoots Himself to Death with Pistol in Washroom Legal Building." February 25, 1931.

———. "Group Forms Coalition to Assure Equal Justice." March 31, 1992.

———. "In the End, Medford Case Proves a Study in Years of Absolute Corruption." May 8, 2008.

———. "Jackson Gets Death: Federal Jury Sentences Styles Killer." May 10, 2001.

———. "Jackson Hopes New Trial Will Clear Son." April 4, 1998.

———. "Judge Orders Examination of Highland Nurse." April 14, 1948.

———. "Medford Case Goes to Jury." May 15, 2008.

———. "Medford Denies He Got Payouts." May 13, 2008.

———. "Miss Hall to Be Sent to Rest Institution." April 16, 1948.

———. "Mummy in Shop Here Held Grim Secret." September 21, 1930.

———. "Nurse Testifies She Discovered Hospital Fire." March 27, 1948.

———. "Owens Pleads, Dodges Death." April 28, 2017.

———. "Owens Pleads Guilty to Codd Killings, Avoids Death Penalty." April 27, 2017.

———. "Pelley's School Will Use Women's Club Here." June 3, 1932.

———. "Police Seek Last Hour of a Life." February 18, 1987.

———. "Retrial Ordered in Styles Killing." April 4, 1998.

———. "Robert Jason Owens to Appear in Court on Zebb Quinn Murder Charge." July 11, 2017.

———. "Sanitarium Here to Be Occupied by School." September 21, 1932.

———. "SBI Checks Items Linked to Slaying." April 19, 1973.

———. "Solicitor Seeks to Bring Pelley Back to State." February 7, 1950.

———. "Speech Delivered by Judge J.C. Pritchard at the Auditorium." September 29, 1907.

———. "State Begins Testimony in Clevenger Case." August 20, 1936.

———. "Strife Trailed Owner of Inn." March 27, 2009.

———. "Suspected Serial Killer Makes Court Appearance." May 13, 1994.

———. "Three New Cases of Polio Are Reported Here." July 8, 1948.

———. "Two Witnesses Tell about Moore Confessing Clevenger Slaying." August 21, 1936.

———. "Von Ruck's Journal of Tuberculosis." October 12, 1899.

———. "Wallace Davis at Home Here after Receiving Parole." April 20, 1935.

———. "Warren Gets Death Penalty." October 7, 1995.

———. "W.D. Pelley, Silver Shirts Founder, Dies." July 12, 1965.

———. "Who's Who in the Medford Investigation." April 28, 2008.

———. "W.L. Clevenger's Testimony at Inquest Here Last Week." July 25, 1936.

———. "Women's Slayings Linked." February 14, 1988.

*Charlotte (NC) News*. "Will Harris Now an Outlaw: Governor Offers $200 Reward." August 14, 1903.

*Chicago Tribune*. "Asheville Police Check Musician's Alibi." July 19, 1936.

———. "5 More Blast Violinists' Alibi in Girl Slaying." July 21, 1936.

———. "Killer of Co-Ed in Hotel Room Must Die." August 23, 1936.

———. "Negro Who Killed 5 Is Dead." November 16, 1906.

*Cincinnati Enquirer*. "Negro Admits Killing of Helen Clevenger." August 10, 1936.

*Coffeyville (KS) Daily Journal*. "A Bogus Lord in Luck." January 4, 1898.

*Cumberland (MD) Evening News*. "Sheriff Says He Has a Number of Witnesses Who Could Contradict Mark Wollner's Alibi." July 20, 1936.

*Evening Republican* (Meadville, PA). "Prohibition Drives Man from Asheville." December 23, 1907.

*Evening Sun* (Hanover, PA). "Pass Key Adds Clue in Slaying." July 21, 1936.

*Daily Mail* (UK). "Construction Worker Charged with Murder of Missing Pregnant Food Network Star and Her Husband after Renovating Their North Carolina Home." March 17, 2015.

*Daily Reporter* (Greenfield, IN). "Girl's Uncle Is Being Held." July 25, 1936.

*Gaffney (SC) Ledger*. "'Will Harris' Killed by Posse." November 20, 1906.

*Gastonia (NC) Gazette*. "Mental Institution Patients Perish on Blazing Top Floors." March 11, 1948.

GoUpstate.com. "Car May Hold Clus to Murder." August 30, 1989. www.goupstate.com/article/NC/19890830/News/605196115/SJ.

*Greensboro News and Record*. "Confessed Killer Made Others Care." July 28, 1990.

*Greenville News*. "News Anchor Acquitted of Arson." March 20, 1992.

———. "Warren's Confession Detailed by Detective." September 15, 1993.

*Hendersonville Times-News*. "Richmond Hill Inn Fire Damage Estimated at $7M." March 6, 2009.

———. "Styles' Killer Could Be Out in 20 Years." March 7, 2000.

*Indianapolis Star*. "Pelley, Man Who Died for Seven Minutes Says Pyramid Predicts Career End in '45." December 28, 1940.

*Insurance Journal.* "Insurer Refuses Payment, Alleging Fire at North Carolina Inn Was Set." March 5, 2010.

*Kokomo (IN) Tribune.* "Silver Shirt Leader Still Bouncing Around, Writing." August 11, 1955.

*Lansing (MI) State Journal.* "Pass Key Clue in Slaying of Young Co-Ed: Sheriff Promises to Crack Carolina Hotel Murder Case Wide Open." July 21, 1936.

*Marion (AL) Times-Standard.* "Lord Beresford's Final End." May 17, 1907.

*Monroe (NC) Journal.* "Will Harris Has Escaped." August 18, 1903.

*Morning Call* (Allentown, PA). "Negro Hall Boy Admits Killing Helen Clevenger." August 10, 1936.

*Mountain Xpress.* "Federal Court Jury Finds Owners at Fault for Richmond Hill Inn Arson, Citizen-Times Reports." December 22, 2012.

———. "Historic Pearson House Demolished." February 2, 2012.

———. "New Age Nazi." January 28, 2004.

———. "Stand by Your Man." March 26, 2008.

*New York Times.* "Travel Advisory: Thomas Wolfe's House Is Damaged by Fire." August 16 1998.

*People Magazine.* "Food Network Star Murders: Handyman Pleads Guilty." April 28, 2017.

*Petaluma (CA) Argus-Courier.* "70 Banks in South Close." November 21, 1930.

*Philadelphia Inquirer.* "On the Riviera, the Haunts of Scott and Zelda." August 28, 1983.

*Robesonian* (Lumberton, NC). "Former Asheville Mayor Ends Life." February 26, 1931.

Ross, Steven J. Ross. *Hitler in Los Angeles: How Jews Foiled Nazi Plots Against Hollywood and America.* New York: Bloomsbury Publishing, 2017.

*Semi-Weekly Citizen* (Asheville, NC). "Bullets of Avengers End Negro Desperado's Career." November 16, 1906.

Shaw, Amanda. "Sheriff Releases New Details in Leicester Couple's Deaths." Fox Carolina. April 17, 2015. http://www.foxcarolina.com/story/28572733/buncombe-co-deputies-to-release-details-on-leicester-couples-deaths.

*Statesville (NC) Record.* "A Desperate Situation and Its Cause." December 8, 1930.

*St. Louis Star and Times.* "Says Eliminating Sweets Provides Immunity to Polio." August 5, 1948.

*Sun* (Baltimore, MD). "Lea Is Sentenced to 6 to 10 Years." August 26, 1931.

*Tampa (FL) Tribune.* "Former Mayor, in Bank Case, Kills Himself." February 26, 1931.

———. "Lea Given Prison Term in Bank Case." August 26, 1931.

Terrell, Bob. *The Will Harris Murders.* Alexander, NC: Land of the Sky Books, 1996.

United Press. "Authorities Arrest Suspected Serial Killer." July 20, 1990.

*Washington Post.* "On Murderer's Trail: Slayer of Asheville Policemen at Bay in Biltmore." November 15, 1906.

# INDEX

# ABOUT THE AUTHOR

*M*arla Hardee Milling is a native of Asheville and seventh-generation Buncombe County resident with ancestors on both sides of her family going back many generations in Western North Carolina. Her Scotch-Irish, German, French and English ancestry runs deep in her veins. Her mother's side arrived in WNC by the late 1700s. Her fourth great-grandfather John Weaver was one of the first settlers to the region. Her maternal grandfather, W.A. Shuford, grew up in the Big Ivy community, and her grandmother, Bessie Garrison Shuford, lived her early days along Sugar Creek in Democrat. Her dad's side of the family was in WNC by the early 1800s and can trace its lineage to General John Sevier, the first governor of Tennessee.

She's a full-time writer with more than eight hundred published articles and essays. She's a contributing editor for *Blue Ridge Country*, a freelance staff writer for *Match.com* and frequent writer for *Capital at Play*, *Smoky Mountain Living* and the *Asheville Citizen-Times*. Her byline has appeared in a wide range of publications, including *Our State*, *WNC*, *AAA GO Magazine*, *Luxury Living*, *NICHE*, *American Style*, *Redbook*, *Parenting*, *Health*, *Kid's Heath*, *Women's Health & Fitness*, *Denver*, *Charleston*, *New Orleans Gourmet*, *Chocolate for a Woman's Soul II* and many others.

Previously, she spent ten years as a news producer at WLOS-TV in Asheville and six years as director of communications at Mars Hill College (now University) in Mars Hill, North Carolina. She currently serves on the board of the North Carolina Room at Pack Memorial Library.

She grew up in Skyland in south Buncombe County, where she graduated from T.C. Roberson High School. She earned a bachelor's degree in communications with a minor in political science from the University of North Carolina at Asheville. She has two children, Ben and Hannah.

She's written two previous nonfiction books: *Only in Asheville: An Eclectic History* and *Legends, Secrets and Mysteries of Asheville*. Find her online: www.marlamilling.com | @marlamilling | facebook.com/marlamilling.